TREE-TALK

MEMORIES, MYTHS AND TIMELESS CUSTOMS

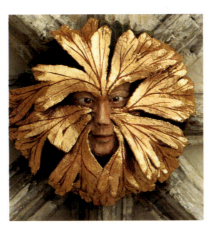

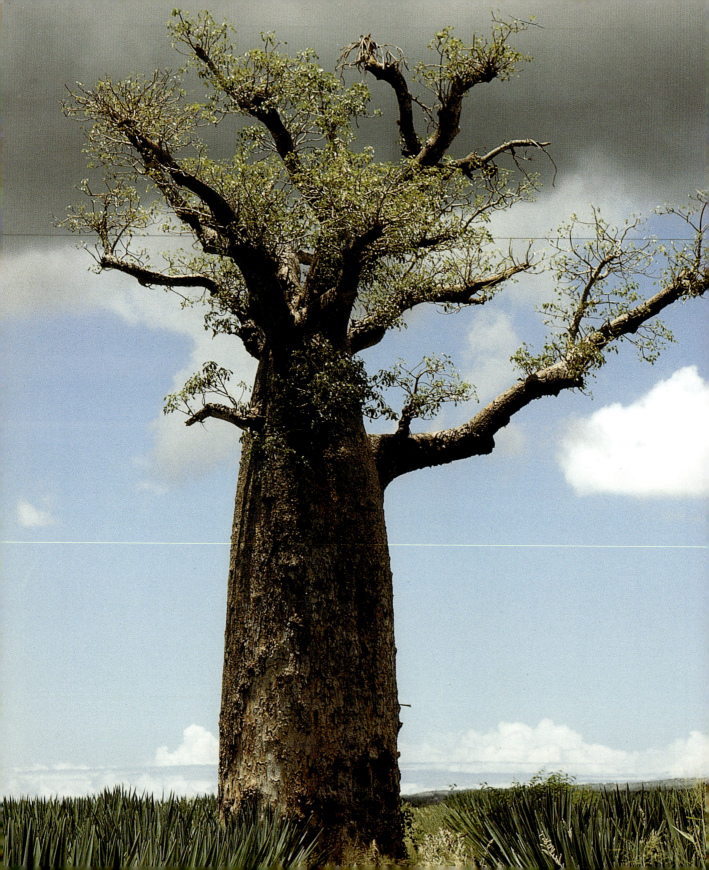

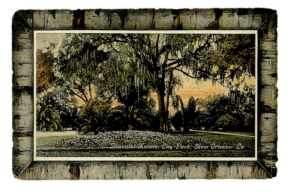

TREE-TALK

MEMORIES, MYTHS AND TIMELESS CUSTOMS

MARIE-FRANCE BOYER

130 ILLUSTRATIONS,

121 IN COLOR

THAMES AND HUDSON

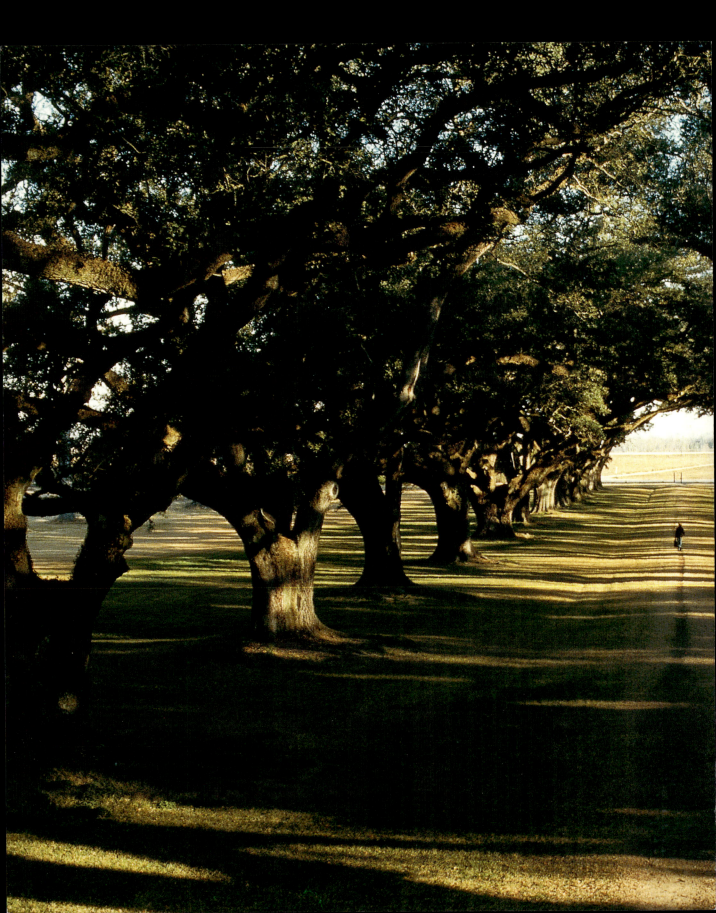

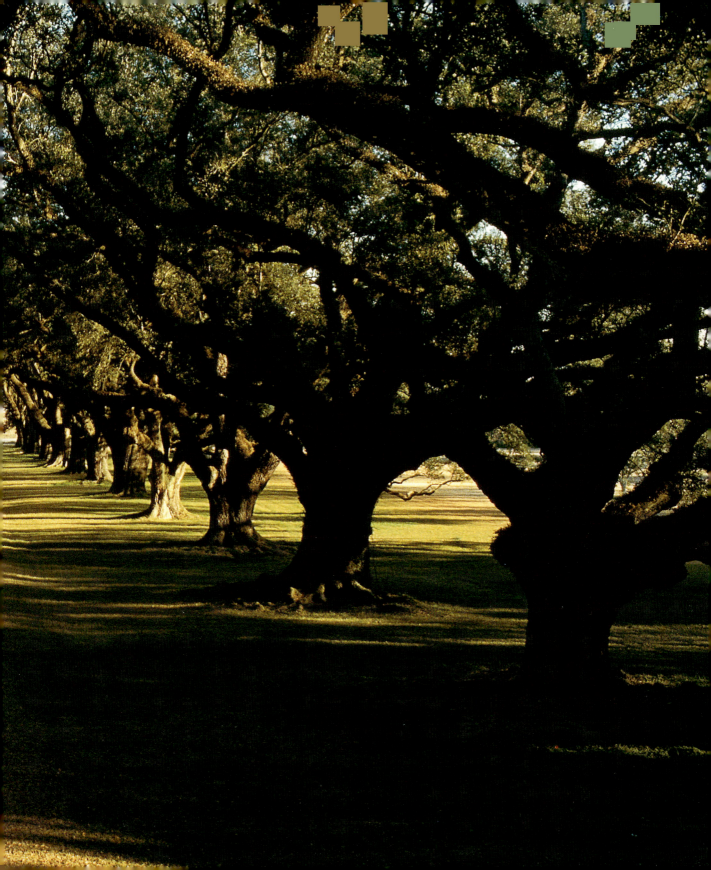

THIS BOOK IS DEDICATED NOT TO BOTANISTS, NOR TO DENDROLOGISTS,

NOR EVEN TO GARDENERS, BUT TO IGNORANT DREAMERS AND TO THOSE WHO LOVE

A SPECIAL TREE, UNIQUE IN ALL THE WORLD.

DESIGNED BY MICHAEL TIGHE

Picture research by Marie-France Boyer and Georgina Bruckner
Translated from the French by Muriel Zagha

© 1996 Thames and Hudson Ltd, London
Published in France in 1966 by Thames & Hudson SARL Paris as *Le Langage des arbres*
English translation © 1996 Thames and Hudson Ltd, London

First published in the United States of America in 1996 by Thames and Hudson Inc.,
500 Fifth Avenue, New York, New York 10110
Library of Congress Catalog Card Number 96-60251
ISBN 0-500-01729-8

Printed and bound in Great Britain

Frontispiece: the Green Man, 1415, in the cloisters of Norwich cathedral. *Page 2:* a centuries-old baobab in Madagascar. *Title page:* mossy oaks, New Orleans. *Pages 4–5:* the author in an avenue of hundred-year-old oaks, Oak Valley, Louisiana. *Page 6:* a beech tree, Kenwood House, London. *Contents page (left to right):* Antonio Pollaiuolo, *Apollo and Daphne*; a ficus in Palermo; a knot in a hazel twig; a chestnut tree that has been struck by lightning; the Allouville oak. *Pages 8–9:* Louis XV and seven courtiers costumed as yew trees for a Versailles ball, 1745.

CONTENTS

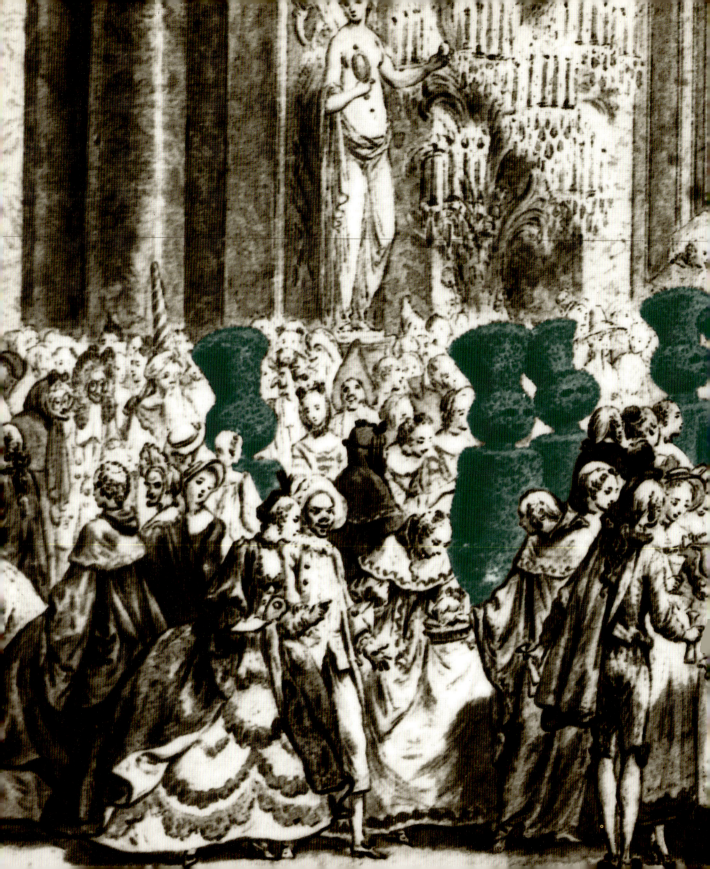

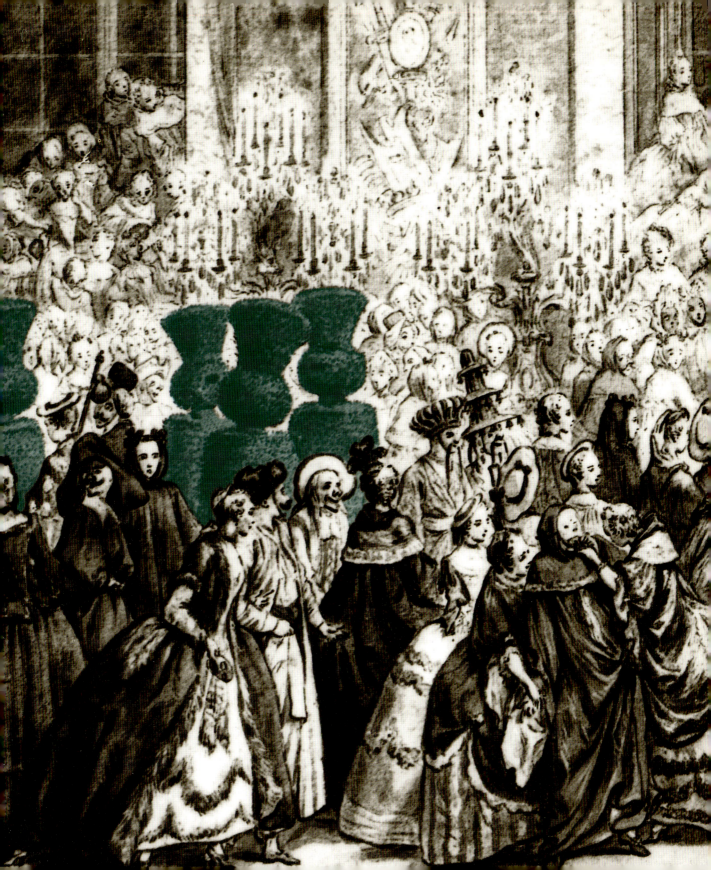

We remember with pleasure the scented yellow mane of the linden tree in flower in June, humming with insects. We contemplate the strong, straight trunk of the beech and the gnarled and spidery interlacing of its mossy roots. We see in the mind's eye the rowan's surprising flash of coral on the yellow grass of a high plateau in August; the powerful, furrowed trunk of the hundred-year-old oak; the unexpected bounty of the paulownia's blue flowers in the heart of the city in May; and the double line of great chestnut trees leading to a château in the snow.

It is not necessary to travel far, or to know much about botany or dendrology, to understand the magic of trees. Poets, painters, writers have all paid them homage. In France in 1930 six thousand 'remarkable trees', trees that were larger, older, more majestic than the rest, or that had been witnesses to 'important' events, were

PREFACE

recorded by the Commission des Sites, an organization that normally concerns itself with the listing and protection of buildings. Every year more of these 'remarkable' trees are cut down or mutilated by storms, road-widenings or alterations to crossroads. The official attitude is that in a city like Paris it is almost impossible to keep these living, growing organisms under control: they are always getting too big or too untidy.

In addition to these monuments of nature, there are the anonymous trees, each with its own harmony, its own history, its own strangeness. Every one of us knows a particular tree that he or she secretly reveres. Near Beauvais, there is a magnolia whose roots must surely conceal a treasure. There is an oak in Burgundy beneath which a dog who returned on foot from the Spanish Civil War lies buried.

J. W. Clarke

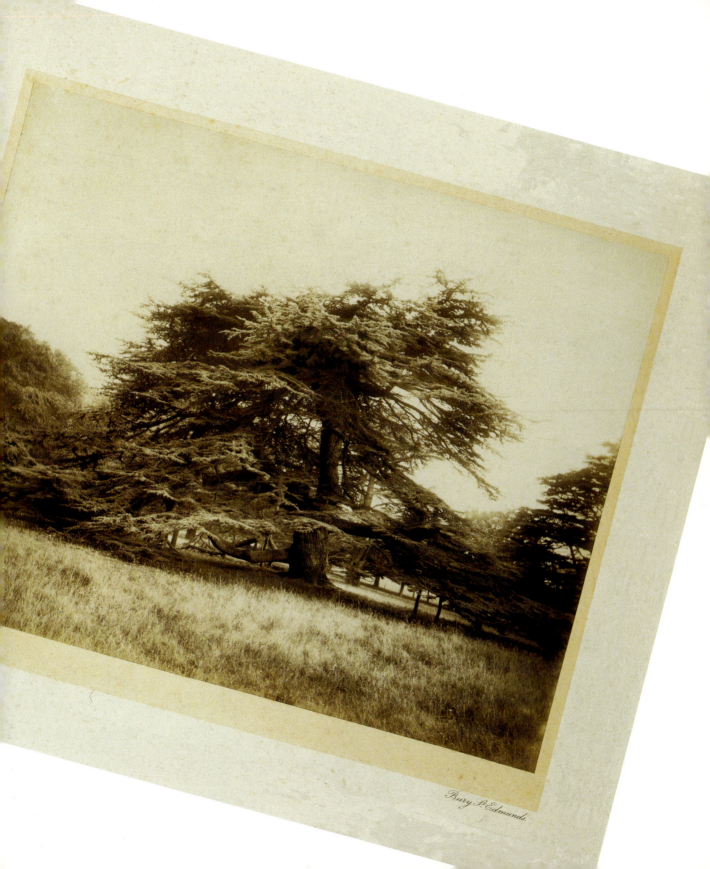

Bury St. Edmunds.

In the north of Argentina, there is a withered tree which swarms with chattering green parrakeets. In Maine, a deep emotion swept the whole region when Dutch elm disease threatened the elms whose leaves turn a brilliant gold in the autumn.

But do trees really matter to us nowadays? They are cut down. They are forgotten. Only a few of the sixty thousand Liberty trees planted in village squares during the French Revolution survive today. They were felled because they were 'in the way'. Yet these admirable specimens, for all their apparent diffidence, still impress us deeply. Trees have been the object of cults in almost every great civilization. They have provided weapons for great armies, ships for royal navies; they have given shape to village squares, provided shade for debates and fêtes, sheltered hermits, guided pilgrims. Like venerable ancestors, they deserve our respect. At the very least, we should take an interest in them, whether we are among those few eccentrics who go out at night to talk to them, or among the legion who cannot tell an oak from an ash. This book is meant for people at both ends of the spectrum.

FOR THE SENSITIVE AND IMAGINATIVE MAN WHO LIVES

AS I LONG HAVE LIVED, NEVER CEASING TO FEEL AND TO IMAGINE, THE WORLD AND

EVERYTHING IN IT ARE IN A SENSE DUPLICATED.

HIS EYES SEE A TOWER, A STRETCH OF COUNTRYSIDE, HIS EARS HEAR A BELL.

IN HIS IMAGINATION, IT IS ANOTHER TOWER, ANOTHER COUNTRYSIDE

THAT HE SEES, IT IS ANOTHER SOUND THAT HE HEARS, AND IT IS IN THESE ECHOES

THAT ALL THE BEAUTY AND CHARM OF THINGS RESIDE.

GIACOMO LEOPARDI

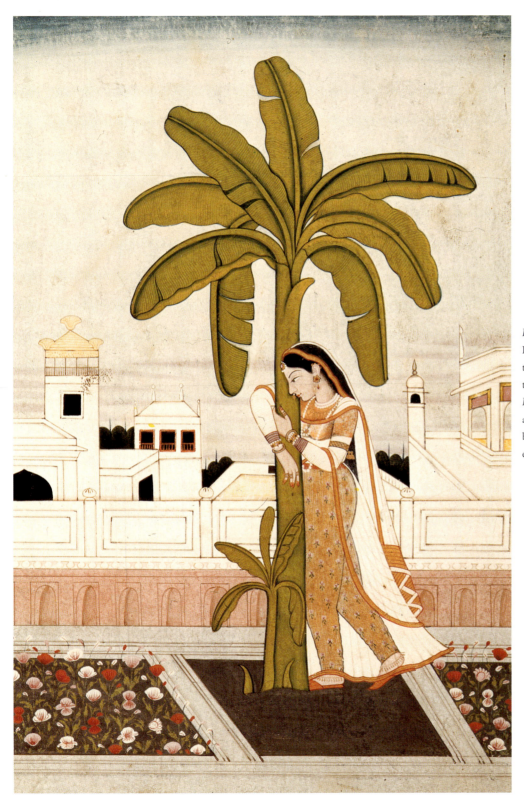

Page 11: the princely cedar of Lebanon, whose wood was used for the columns of King Solomon's temple, arrived in Europe in 1630. *Left:* a young woman, pining for her absent love, embraces the trunk of a banana tree in this Indian miniature, early nineteenth century.

13

t is the Cosmic Tree, which we also call the Tree of Life, that has always represented the axis of the universe. Its summit touches the sky; its roots, the pillars of the world, reach deep into the centre of the earth, the kingdom of the dead, giving birth to springs and rivers. In this way the tree unites the nadir with the zenith. Its leaves are beautiful and useful, its fruit nourishing and good to eat; its shade is kind and its branches give shelter to all the animals of creation.

Following the rhythm of the seasons, the tree, like the phoenix, regenerates itself, and therefore appears to be immortal. It is clear from oral and written histories, literature, painting, sculpture and songs, that since the dawn of time all ancient civilizations have venerated an almost identical tree. Symbolizing both the female nurturing principle and the male stem, the tree has the power of 'the great awakener', the power

MYTHICAL AND

to gather all latent energies and to transform them into strong spiritual forces. In Norse mythology, this founding tree is an ash, Yggdrasil – meaning 'steed of Ygg', or Odin, the god who sacrificed an eye to drink from the spring of knowledge. The serpent Niogghr is coiled around its base, and it is from the tree that, in the wake of an infernal cataclysm, the first man and the first woman are born.

In India, the founding tree is the banyan, under which Buddha achieved enlighten-ment – it remains intimately associated with him and symbolizes him; it is also sacred to Hindu gods. For the Chinese, it is the mulberry tree, the universal essence shelter-ing the mother of the sun, a hermaphrodite which stands in time before the division into Yin and Yang, male and female, light and dark, sky and earth. The Phoenicians derive their name from the phoenix palm, the sacred tree acknowledged by the

Sumerians and the source of all the riches of the Middle East from Iraq to the Sahara. The Mexicans venerated a tree from which sprang a mother goddess, with the plumed serpent of death and renewal on her right, and on her left a green god of vegetation.

The inhabitants of Siberia revere the pine but more frequently the silver birch. The souls of their ancestors shelter in the knots of its trunk, to which the gods tie their horses. During the shaman's initiation ceremony, he must make a symbolic ascent of the silver birch 'to the seventh heaven' in order to communicate with the Supreme Being.

This mythical ascent is found in many medieval legends: for instance, Merlin the Enchanter climbed to the top of a pine in the Broceliande forest to attain knowledge.

MYTHOLOGICAL

The Egyptians see the nurturing goddess Nut emerge from a sycamore fig, distributing the bread and water of eternity to the souls of the dead who perch on its branches. The fig tree, most prolific of trees, is the founding tree of Rome: when Romulus and Remus were thrown into the Tiber, their cradle grounded itself under a wild fig, which also shaded the she-wolf who suckled them.

The olive tree, mentioned in Genesis, was venerated by the Israelites and also the whole of Asia Minor. For the Arabs it stands at the centre of the world; the source of life, it symbolizes Abraham. It is the olive tree that the prophet Mohammed climbed in a dream, overcome by the beauty which was revealed to him. The olive tree is also the founding tree of Athens; the maternal and nurturing source, endowed with the power of rebirth from its own dead stump, was planted by Athena on the Acropolis

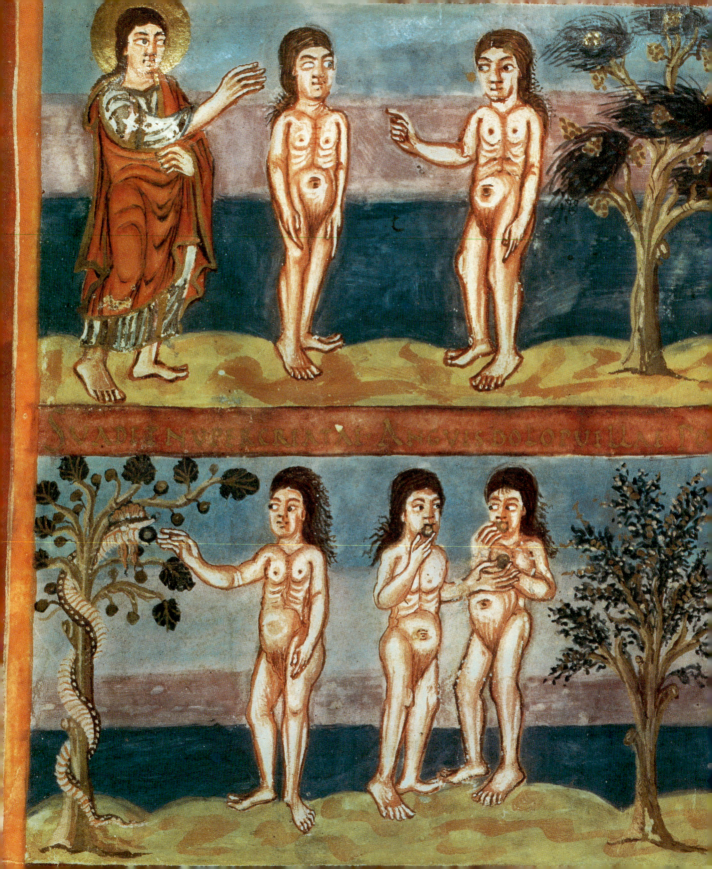

ꟾIC ADEꟾ NVꟾ KCREATAꟾ ANGVꟾꟾ DOꟾO PVELLAꟾ PA

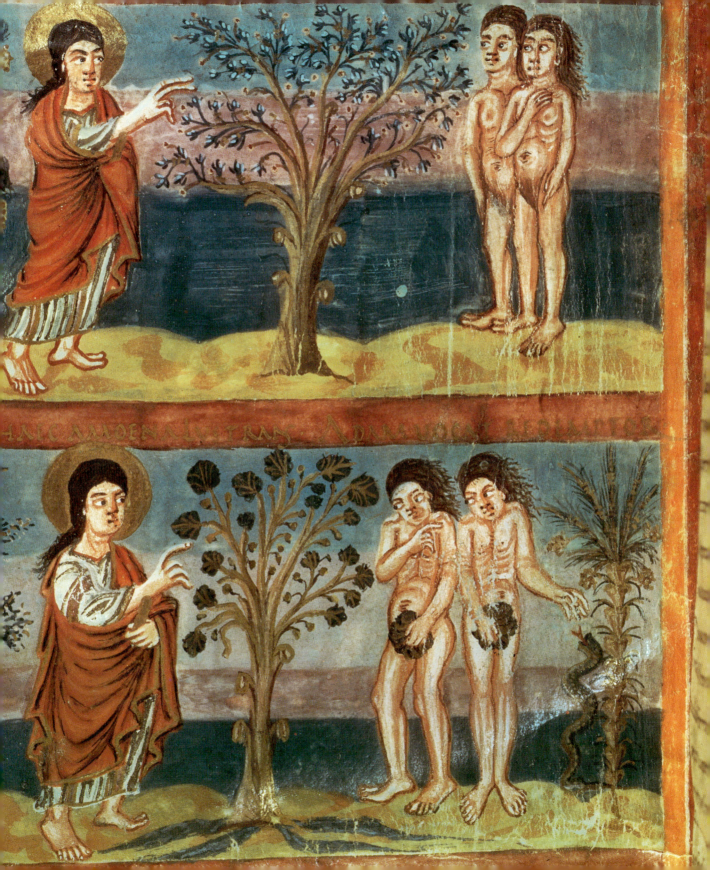

ANTE AMOENA IN TERRAS ADAM ISCAT REPLANTES

in contest with the salty spring that Poseidon struck from the earth. The tree appears in so many ancient myths. The Tree of Knowledge in the Garden of Eden is central in Genesis, the first book of the Old Testament. Was this an apple tree, a fig tree or a palm tree? Pictorial representations and critical interpretations contradict one another; the only constant element is the serpent, like Niogghr of Yggdrasil, the fatal tempter. The story of Adam and Eve's expulsion from Eden for tasting the fruit of the Tree of Knowledge of Good and Evil is well known, but it is generally forgotten that God placed angels with swords of fire to guard the Tree of Life.

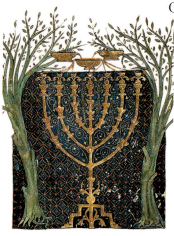

One of the twelve labours of Hercules was to steal the golden apples from the Garden of the Hesperides; these apples bestowed the precious gift of immortality. But first he had to overcome, among other obstacles, another incarnation of the dragon-serpent, who protected the tree given to Hera as a wedding-gift by the earth-mother goddess Gaia. The bond between tree and man still holds fast. Ovid, in his *Metamorphoses*, tells how every tree conceals a nymph transformed by grief or virtue. Daphne, the most famous, turned herself into a laurel to escape Apollo's ardour. Leuce became a poplar, Pitys a pine. Overcome with shame at giving birth to a centaur, Philyra took the form of a linden tree, like her, endowed with the power of healing. Shame also turned Myrrha into a tree; bewitched by Aphrodite, whom she hated, she had seduced her own father. From her trunk she gave birth to Adonis in a shower of scented drops. The metamorphosis of Philemon and Baucis was the happiest tale: the old and loving couple unwittingly offered their hospitality to Zeus who, after their death, turned them into an oak and a linden tree so that they should never be parted.

Page 15: Adam and Eve, and palm tree. Spanish, *c.* 1000. *Pages 16–17:* tempted by the serpent, Eve eats the fruit of the Tree of Knowledge in this ninth-century 'comic strip' (Tours). *Left:* like the Native American totem or the Christian cross, the Jewish seven-branched candelabra (menorah) is based on a tree. Spanish miniature, 1299. *Opposite:* during his campaign to conquer Asia, Alexander the Great encounters a tree which talks to him, reproaching him for his excessive ambition. Persian miniature, fifteenth century.

18

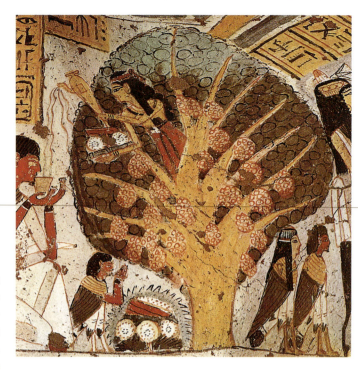

Above right: the goddess Nut dispenses the elixir of immortality from the Egyptian Tree of Life – a sycamore fig. Sixteenth to fourteenth century BC, Thebes. *Below:* gallants compete to charm the delicious treasures of 'the tree of beautiful fruit'. Seventeenth-century French engraving. *Opposite:* Hercules must brave the dragon to win the golden apples of immortality of the Garden of the Hesperides. Hellenistic bas-relief from the Villa Albani, Rome.

L'ARBRE AV BEAV FRVICT

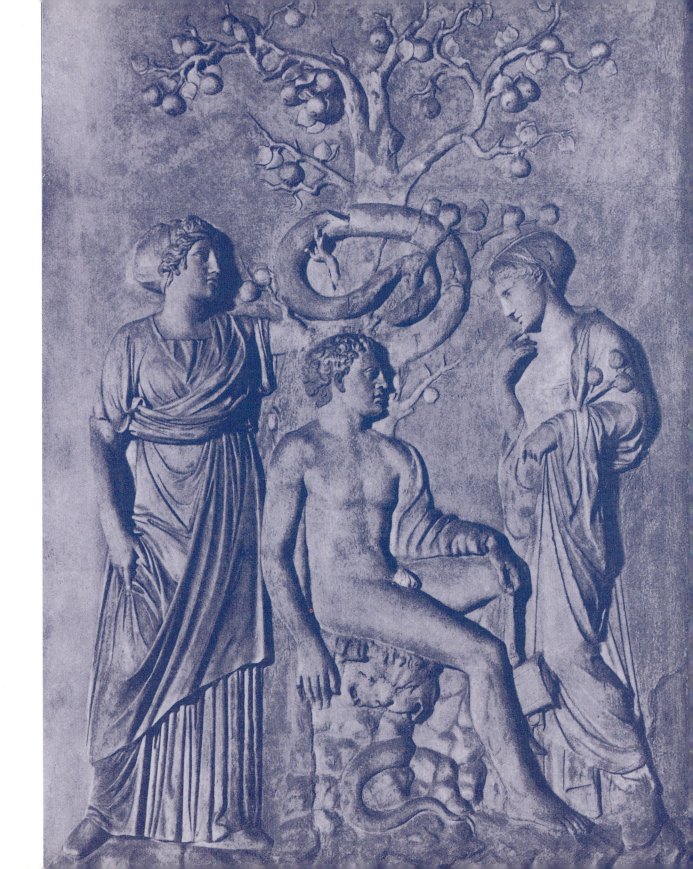

Closer to our own time, the Romans and Celts venerated the oak and the yew. The yew gave warriors the wood for their bows, its branches provided the poison for arrows, and also for suicide. It is under a yew that legend insists that Robin Hood lies buried, with his sword at his head, his arrows at his feet and his bow of yew at his side. Yews still haunt graveyards; some are a thousand years old or more. Their roots, it is said, become charged with the thoughts of the dead which their branches scatter to the winds. The yew's slow growth and the density of its wood allowed it to survive the Ice Age. The Druids believed it was immortal. Some say that the terpene oil contained in its bark is a cure for cancer, which only enriches its legend.

The Christmas tree, a fir tree in Europe (but an araucaria in the Canary Islands), first appeared in Germany in the eighteenth century. It spread throughout Europe in the nineteenth century and still perpetuates the tradition of the tree as symbol of fecundity and happiness, a happiness which, in certain periods, took the form of liberty: sixty thousand trees (many of them linden trees) were planted in France in 1792 as a promise of better days, free from the yoke of tyranny. A century and a half later, at the end of the Second World War in 1945, trees were once more planted as a sign of liberty.

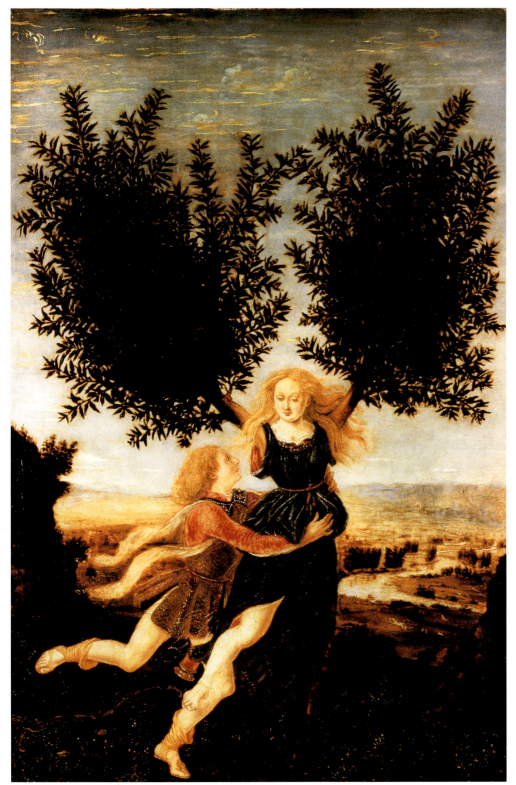

Opposite: fleeing from Apollo's ardour, Daphne is transformed into a laurel. Coral, silver-gilt and precious stones, Wenzel Jamnitzer, German, sixteenth century.

23

Left: Apollo and Daphne by Antonio Pollaiuolo, fifteenth century.
Above: Aziza, god of the forest, by Cyprien Tokoudagba, 1992.

24

Below: Zeus metamorphosing the nymphs, woodcut from *The Dream of Poliphilus* by Franceso Colonna, fifteenth century.

Right: Myrrha, ashamed at her incestuous love for her father, is transformed into a tree, and gives birth to Adonis bathed in sweet-smelling drops of resin.

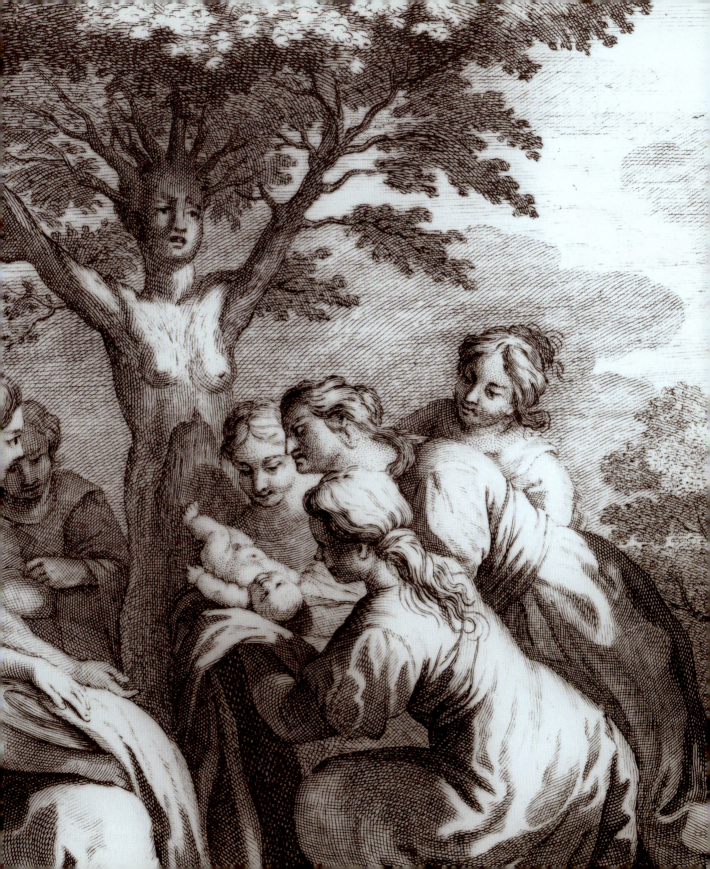

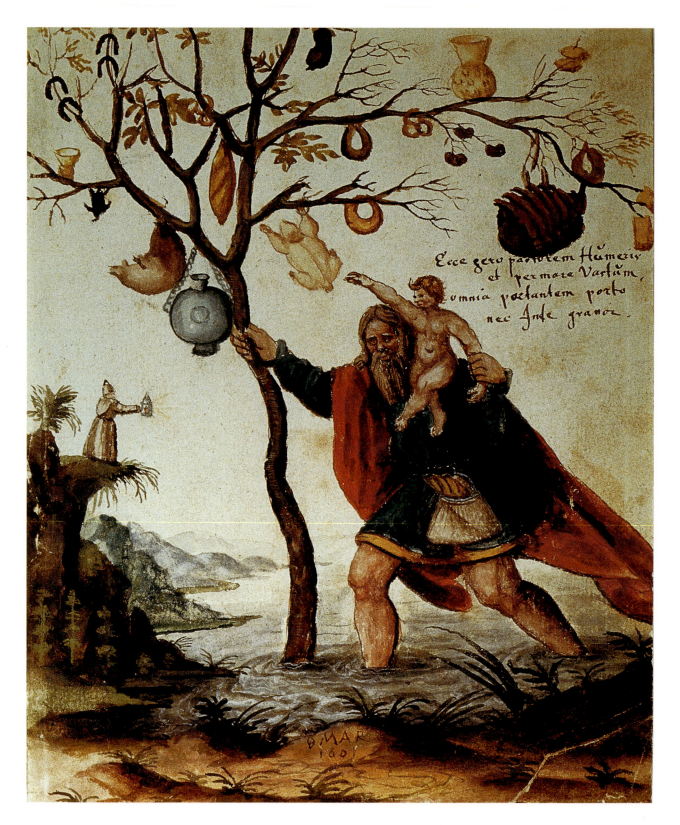

Ecce gero partotem Humeir
et permare Vastum,
omnia portantem porto
nec Ande granoz.

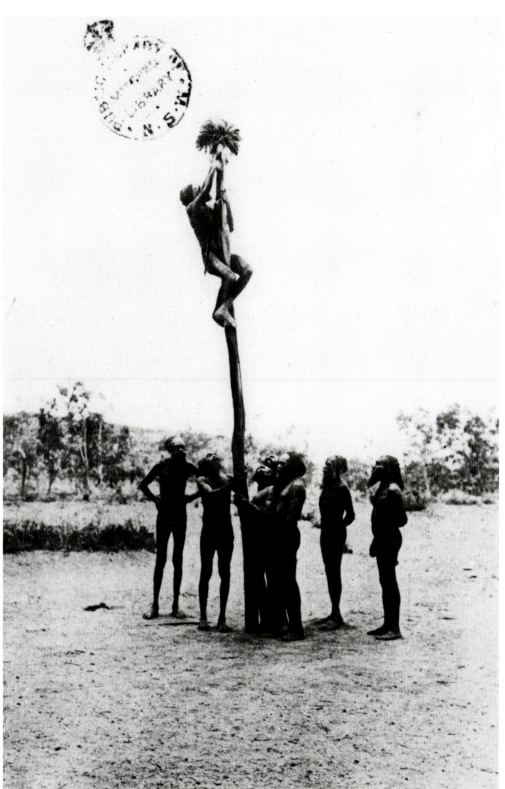

Opposite: St Christopher shakes the tree of offerings (German, 1601), a version of the 'greasy pole', and a promise of plenty, like the Christmas tree, *above,* an araucaria in Hierro in the Canary Islands. *Below:* the tree marking the election of new local councillors at St-Just in Cantal. Climbing the tree or the totem is a promise of happiness in all cultures. *Right:* erecting the sacred pole of the Arunta tribe, Australia.

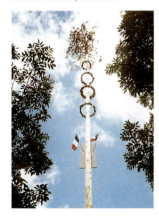

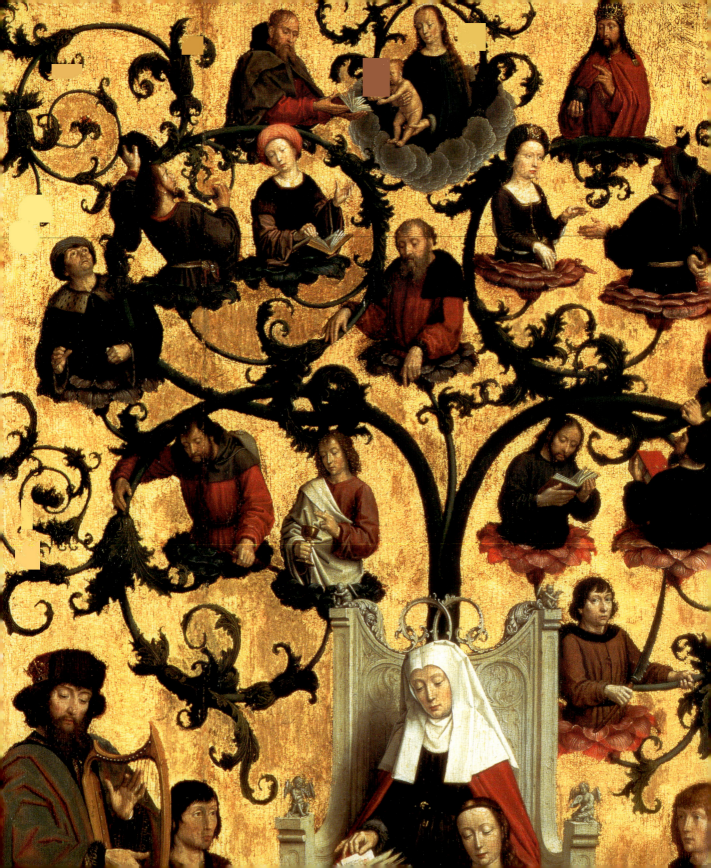

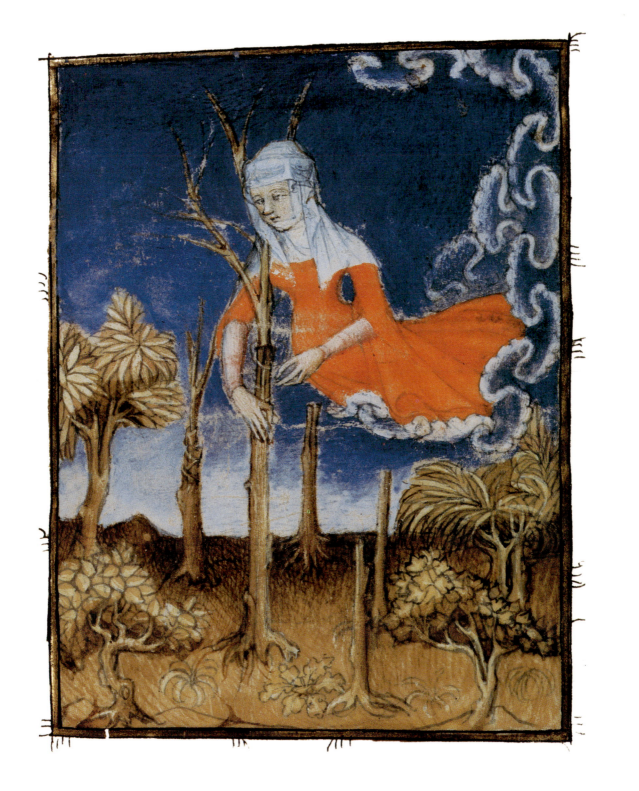

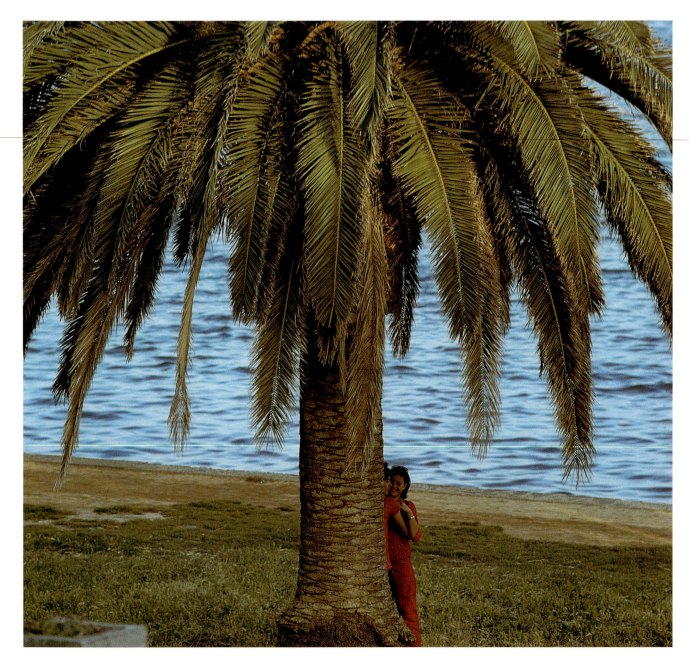

Page 28: St Anne's genealogical tree, a fertility symbol, Gerard David, French, fifteenth century. *Page 29:* allegory of the Immaculate Conception: Isis grafting on to a tree trunk. Miniature, from a manuscript of Christine de Pisan's works, French, fifteenth century. *Left:* palm tree, Italy; *right:* palm tree, Egypt. The palm tree was the Cosmic Tree, the axis of the world. It was cultivated in Mesopotamia as early as six thousand years ago, and its fruitfulness was the salvation of the Mediterranean basin.

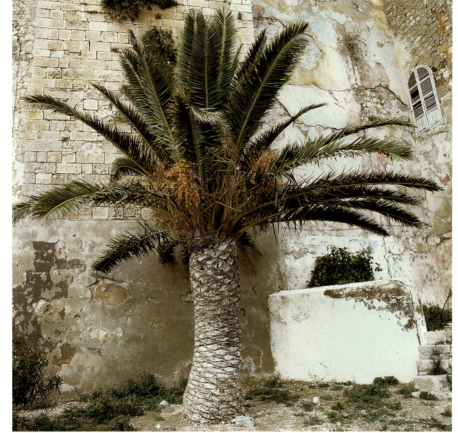

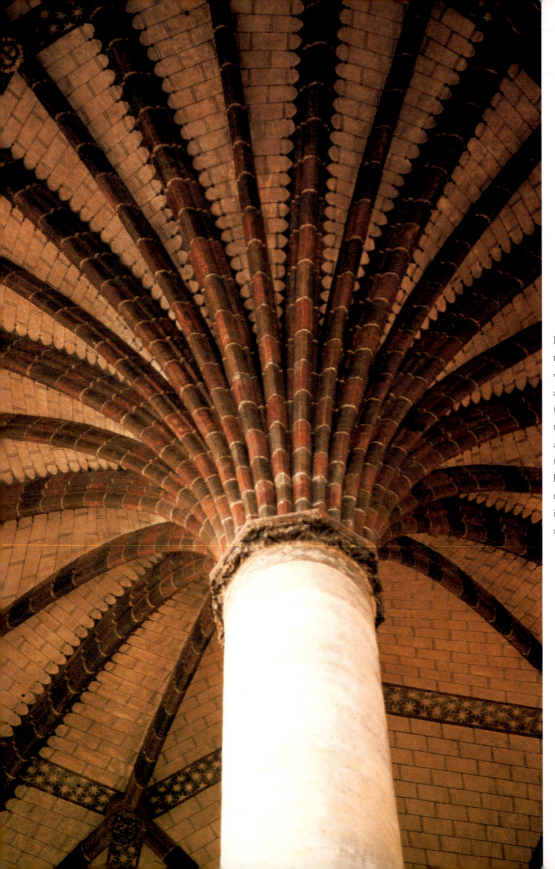

Plutarch wrote songs dedicated to the glory of the palm tree, a tree which has been an inspiration for all the arts, from architecture (the vault in the form of a palm tree in the church of the Jacobins at Toulouse, *left*) to ceramics (Portuguese tiles, *right*). Linked by its name (the phoenix palm tree) to the phoenix, the mythical bird, it too is said to be immortal and to rise again from its own ashes.

eople everywhere claim that their community possesses the oldest, the largest or the most beautiful tree in the region, in the country or in the world, whether it is in their village square, on a local great estate or in the forest nearby. Until the eighteenth century, Europeans were convinced that no other tree species could live as long as their ancient oaks. They even believed that these oaks were eternal. But this certainty was shattered as travellers discovered deserts and forests where they found trees as old as mammoths. In the twentieth century, dendrology appears to have become an exact science and teaches us that, if the oldest trees in Europe date back approximately two thousand years, there are yet others that are twice as old. The most up-to-date research suggests that the oldest trees in the world might be the bristlecones, small shrivelled plants of the pine family, which

ANCIENT

are also sometimes called foxtails because of the shape of the ends of their branches; they may be around five thousand years old. They grow at altitudes of between 2900 and 3500 metres (9500 and 11,500 feet) in the White Mountains situated east of California. The Paiute Indians used to live there and fed on their seeds. Bristlecones resist temperatures as low as -40° (C and F), and their gnarled, dry, twisted trunks give the impression of trees that have half died on the rocky terrain. They are very similar to the sabino of Hierro in the Canary Islands which is also reputed to be age-less. There is another exceptional species in Grand Canary, in the monastery of Santo Domingo, and on Tenerife in Icod: the dragon tree, a strange plant whose dark red resin resembles blood. In 1798, the bewildered Friedrich Humboldt estimated that it was eight thousand years old, an age halved by the calculations of modern botanists.

But nobody really knows how old the baobab is, that obese and shiny African patriarch which David Livingstone nicknamed 'the eighth wonder of the world'. In the eighteenth century, the botanist Michel Adanson put the age of the Senegal and Cape Verde baobabs at five thousand years, the same age as that given to the Mexican cypress of Santa Maria del Tule, near Oaxaca: this extraordinary monument, as wide as it is high, is probably made up of several trunks which are kept alive by means of long underground metallic pipes. It is thought that the Douglas fir and the redwood, which is almost as venerable, could be two and a half thousand to three and a half thousand years old. Most importantly, these trees reach a height that no European before the nineteenth century would have dared imagine that a tree could attain. The Founder's Tree, the Dyerville and the Tall Tree, in Redwood National Park, near San

WITNESSES

Francisco, are over a hundred metres (three hundred and thirty feet) high. Their magnificent red trunks, straight and massive, stretch out their lowest boughs fifty metres (a hundred and sixty-five feet) from the ground and their young green branches unfurl 'close to heaven', unreachable to all but the birds. Discovered a little over a century ago, these giants were bewildering to the Americans, who did not at first fully grasp their importance: they were considered freaks of nature, and their bark was exhibited in travelling circuses.

In Europe, a tree is already an object of fascination after two or three hundred years. It has witnessed events that no human now living has seen. This memory is what touches us, even more than a

Preceding page: the sign 'At the Cork Tree' in Paris is all that is left of a shop long gone.

Right, top to bottom: the Major Oak, a five-hundred-year-old oak in Sherwood Forest, said to be where Robin Hood and his companions met; the chestnut tree at Hitzacker in Germany, which covers an area of seven hundred square metres (7500 square feet), and which a witch is said to have planted upside down ; the Hamme-Mille yew at Valduc in Flanders; the thousand-year-old oak of Tronjoly-Callac in France. *Opposite:* the eight-centuries-old English oak at Bowthorpe farm.

Overleaf, from left to right: the hundred-year-old chestnut tree of Ceyroux in Creuse, the oldest tree in the smallest of hamlets; the Angel Oak in South Carolina, perhaps fourteen hundred years old, haunted by slaves' souls; a pomegranate tree, the height of fashion at the time, planted at Versailles in 1680 for Louis XIV.

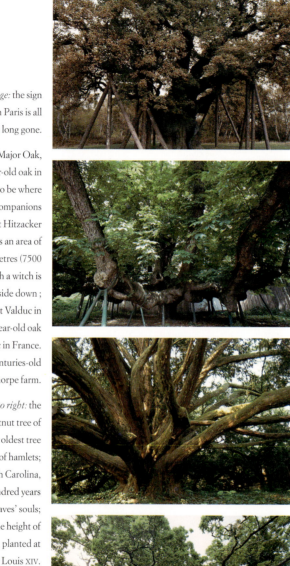

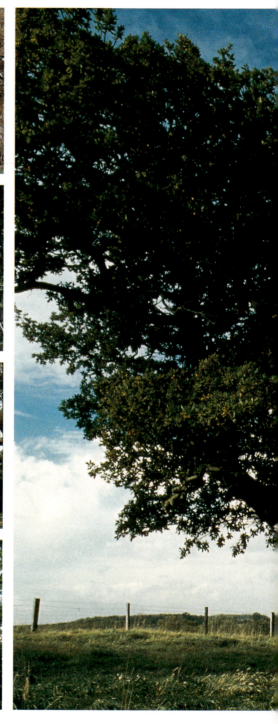

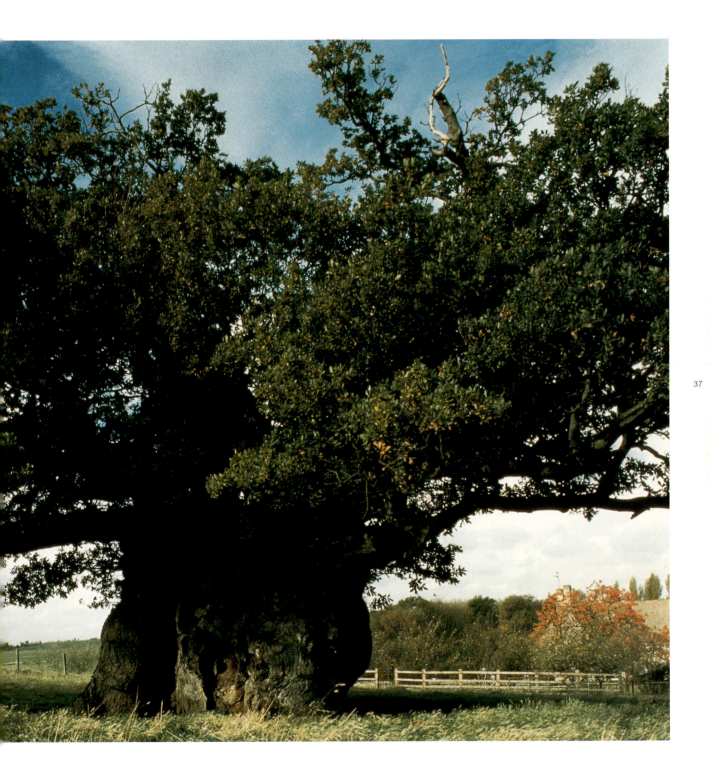

tree's extreme age, its species or its beauty. Besides, is it possible to think of a very old tree as 'beautiful'? The balance of trunk and branches, the symmetrical shape of its boughs (as long as its architecture has not been altered by lightning or human hand) make a three- or four-hundred-year-old oak, elm or linden tree worthy of awe. But as soon as a tree lives beyond this age, its burst trunk – shrivelled, twisted, knotted, or perhaps merely a gaping hollow, a roofless cave sprouting a few branches – becomes an upsetting sight, a parable of the passing of time, an image of a living and yet petrified memory. Such deep furrows, cracked wood and huge distorting knots lead

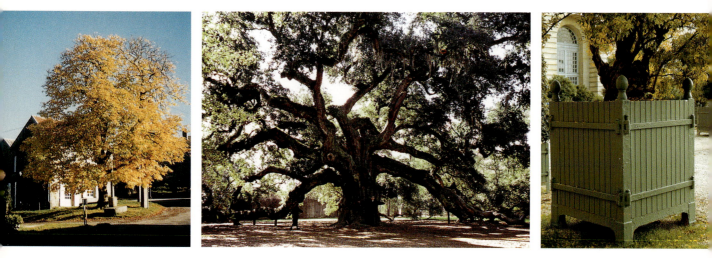

folk wisdom to abandon scientific descriptions in favour of the mythical, poetic or familiar: the tree is given such names as the King of Kings, or perhaps Jupiter, the Beautiful Lord, God's Beech, the Great Master, the Blessed One. Most Europeans choose the language of the emotions to name them, whereas North Americans prefer the heroic appellations of generals or presidents.

In Europe, the oak has long been regarded as the archetypal tree, and this mythical status may well have saved oaks from being cut down. There are still many around that are centuries old. In Denmark, the Royal and the Twisted Oaks of the peninsula

north of Roskilde Fjord are thought to be two thousand years old; they once belonged to an immense forest that covered the whole of northern Europe. There is an oak in the forest of Roumare, near Rouen that was already very old when, in the tenth century, the Norseman, Roland of Normandy, suspended golden necklaces from its branches. The Major Oak in Sherwood Forest in Nottinghamshire is the largest and possibly the most handsome oak of all. Well-rooted in its meadow with a dense canopy of leaves and a sturdy trunk, its perfection is impressive, but it is thought to be no more than five hundred years old; although the age of a tree is

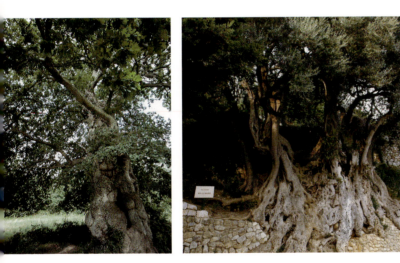

Far left: the Guillotin Oak in the Broceliande forest served as a hiding place for a priest of that name during the French Revolution; it is also told that this is the oak in which the enchanter Merlin was imprisoned by Niniane, to whom he had revealed the secrets of his magic.
Left: the King of Kings, the two-thousand-year-old olive tree of Roquebrune on the Riviera.
Right: the Chaliers linden tree, in Cantal, one of the six thousand trees classified in 1930 as 'remarkable'.

often revised with the more exact scientific methods of today, the myths and legends associated with it do not necessarily disappear.

Let us recount a few of these stories. After his defeat at Worcester in 1651, Charles II escaped from Cromwell's soldiers only by hiding in the branches of a great oak tree, theráfter known as the 'Royal Oak'. The Pavilion Oak, the largest in the Tronçais forest, is the only survivor of the forest that Colbert created in the seventeenth century and that was intended to provide the timber for Louis XIV's ships. In Belgium in Namur, the oak at Triche-en-Gibet, whose name means 'Cheating-the-

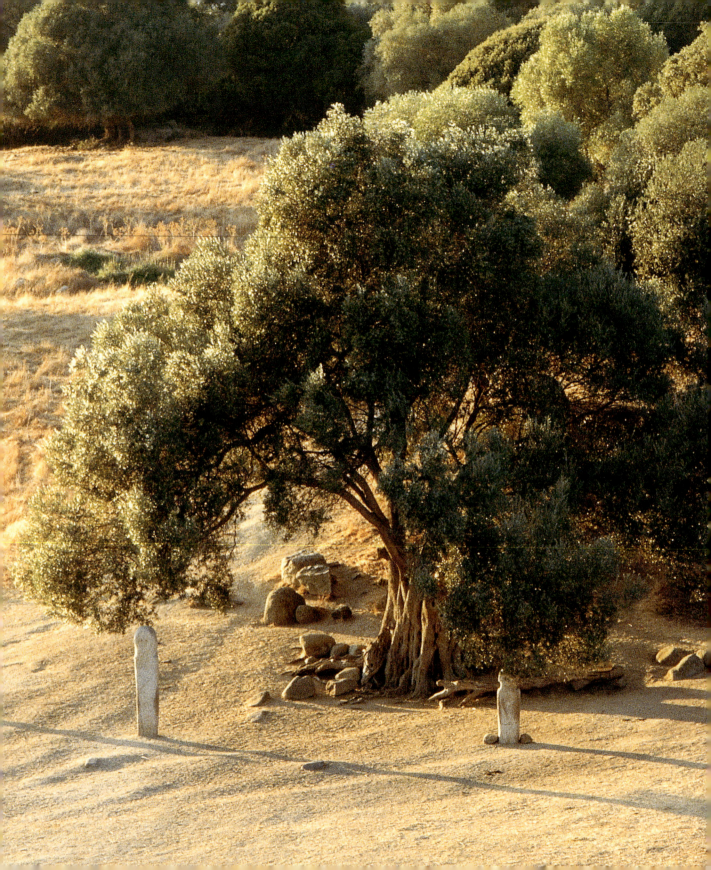

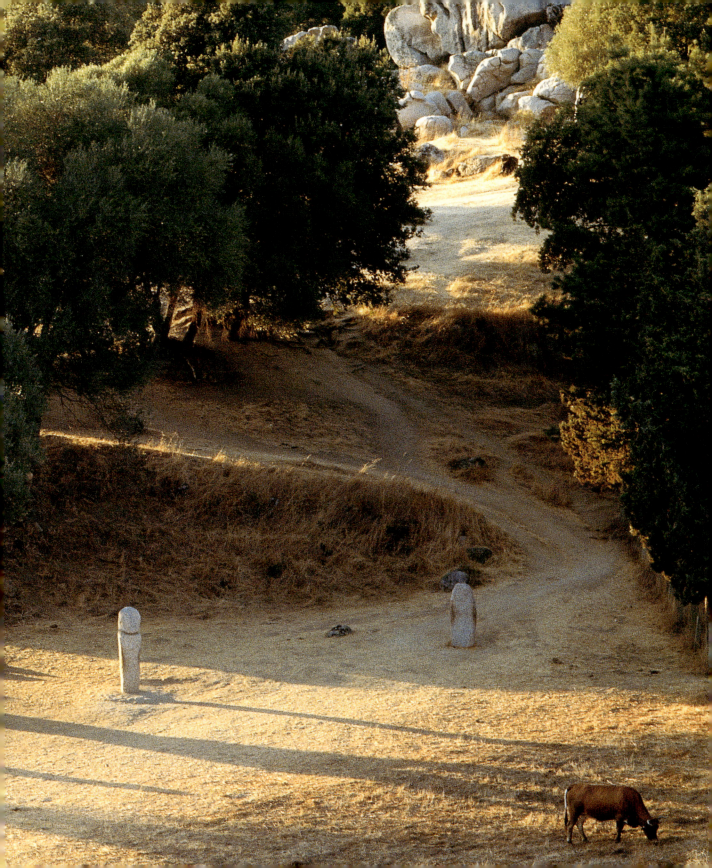

Gallows', is a reminder of a dismal custom. The Angel Oak, near Charleston in South Carolina, despite its name, is not associated with heaven or with heavenly apparitions; rather it is believed to have been planted a century before the arrival of Christopher Columbus in America, and owes its name to a family of planters who lived in the eighteenth century, the Waights, whose daughter married a Mr Angel. With its almost magical aura, the Angel Oak is a popular place of pilgrimage; at night, it is reported that the souls of mistreated slaves have been seen to wander around it.

Less sombre and impressive than the oak, the linden tree (the lime tree), is the tree of love, friendship, gatherings and fêtes. It is therefore easy to collect the many rites and

memories attached to it. In Lower Saxony, the linden tree of Elbrinxen is held to be over two thousand years old, as is the Estry linden in Calvados in Normandy. There is one in Samoëns in the French Alps, thought to be only sixteen hundred years old. A much younger tree, the Ivory linden in the Jura, was planted in 1458 to celebrate the wedding of Marie of Burgundy, daughter of Charles the Bold, while another, planted a few years later in Fribourg, still commemorates that king's defeat: it is, in its own way, a tree that celebrates liberty regained. Linden trees are often an emblem of liberty. In Sagy, Saône-et-Loire, there is one that was planted, so the story goes, by the great Duc de Sully; like so many others it was consecrated as a Tree of Liberty in 1793. There is a linden in Neustadt, Württemberg, in Germany, propped up by a hundred and six stone pillars in close formation, some engraved with the name of the person who erected them. They date back to the sixteenth and seventeenth centuries.

Olive trees, which were mentioned in Crete as early as 3500 BC, only made their way to France much later. The one in Roquebrune-Cap-Martin, on the Riviera, whose tyre-like trunk sags gently, swallowing up the stones around it, is nonetheless two

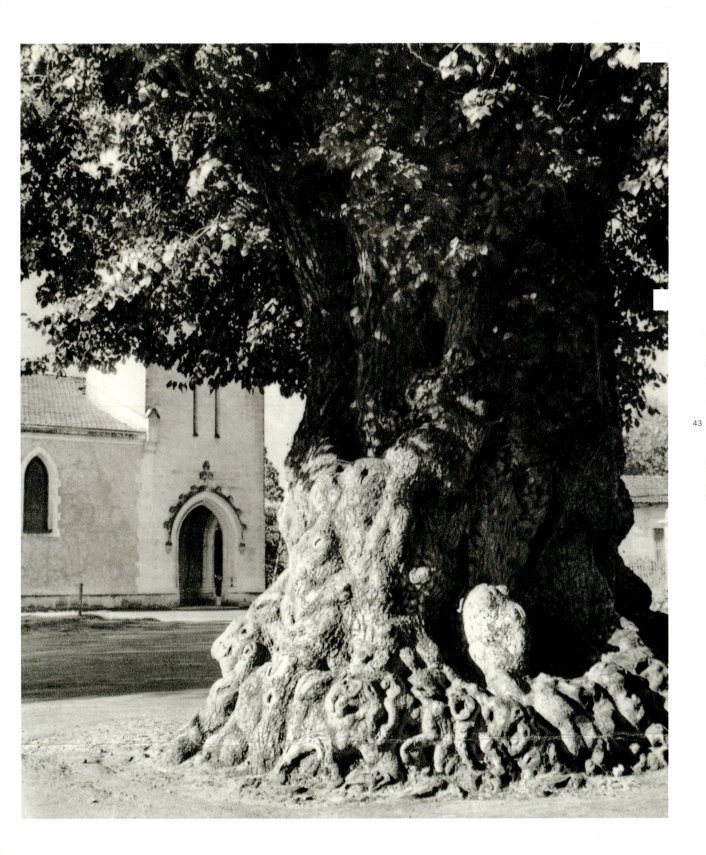

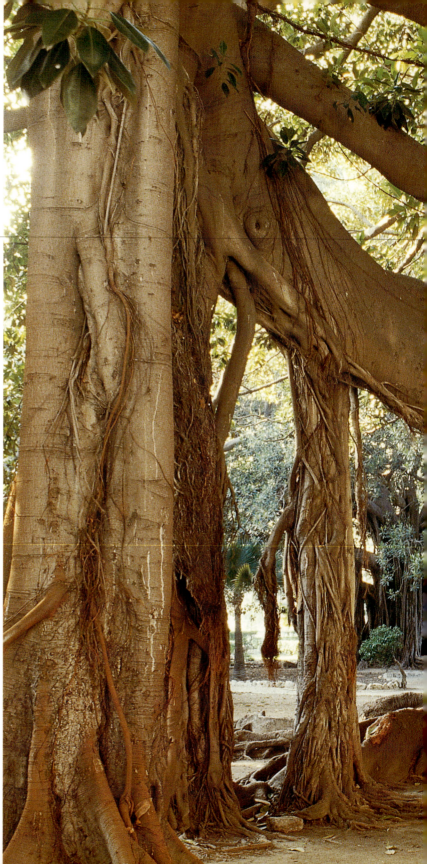

Below: the cypresses of Santa Maria del Tule in Mexico have fused together; they are four thousand years old.

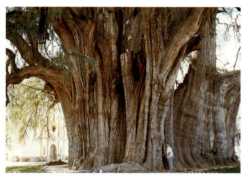

Right: The largest specimens of the ficus in Europe grow in the Place Garibaldi in Palermo.

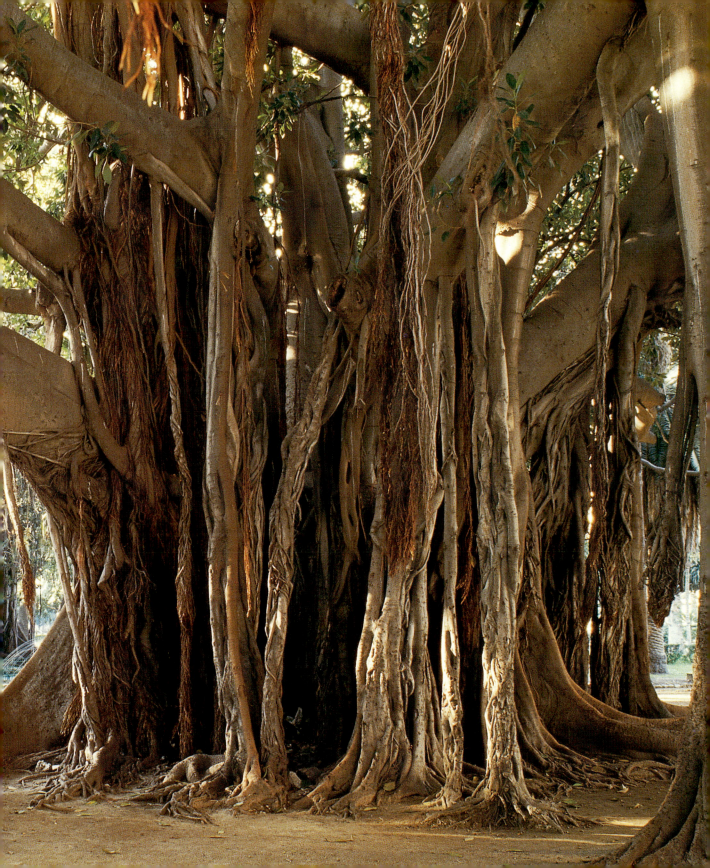

thousand years old, like the olive trees of Nyons in the Drôme region of France, which are clustered in a veritable 'colony'. Sanctified by the Bible, the olive trees of Gethsemane near Jerusalem are thought to have witnessed the agony of Christ. In Sardinia, Calabria and Corsica, olive trees often attain a venerable age, and it is even a common belief that those at Filitosa in Corsica could be as old as the ring of megaliths, the ancient great stones, that surround them.

Cedars and plane trees are similarly 'immigrants'. When Antoine Jussieu introduced the cedar to Paris in 1734, it was already over a hundred years after a cedar had been

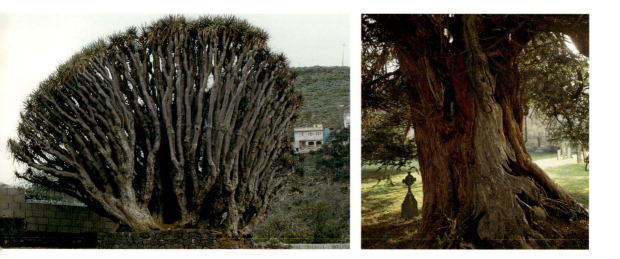

planted (in 1630) at Wilton House, near Salisbury in England. The majestic branches of the cedar inspire admiration: in 1994 the architect Jean Nouvel spared the cedar shading the site where he built the new Cartier Foundation on Boulevard Raspail in Paris; the tree had been given by the beautiful Joséphine de Beauharnais, Napoleon's consort, to Mme de Chateaubriand, a virtuous woman who lived there and was said to do much for the poor. In their natural habitat, in the Himalayas, in Morocco, in Turkey or in the Lebanon, these princes of the Orient – though they are becoming rare – can live to be thousands of years old and grow to heights of thirty to forty

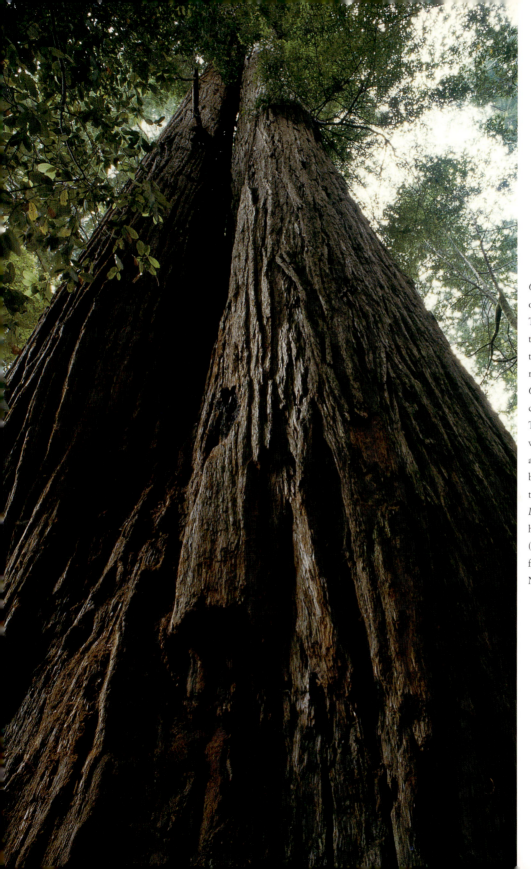

Opposite, left: a dragon tree
on Tenerife in the Canary Islands.
This tree is said to be more than a
thousand years old. Alchemists
thought they could transform the
red gum that flows from it into gold.
Opposite, right: a yew in the
churchyard at Crowhurst in Sussex.
The Druids worshipped yews,
which were associated with eternity
and death, and they were the first to
bury their dead at the foot of these
trees, survivors of the Ice Age.
Left: the tallest tree in the world, one
hundred and twelve metres
(over three hundred and seventy
feet) high, growing in the Redwood
National Park in California.

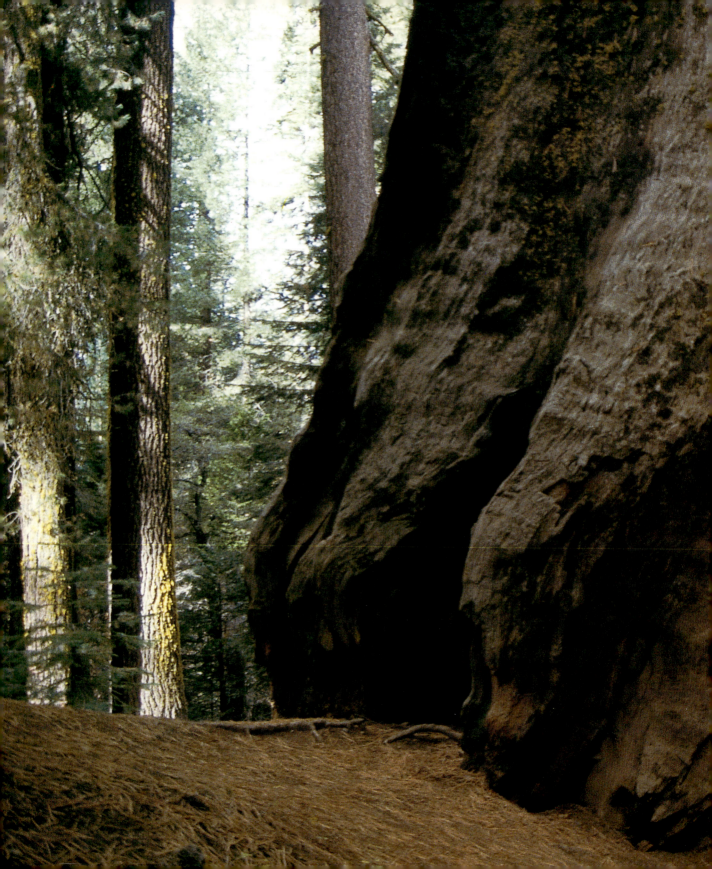

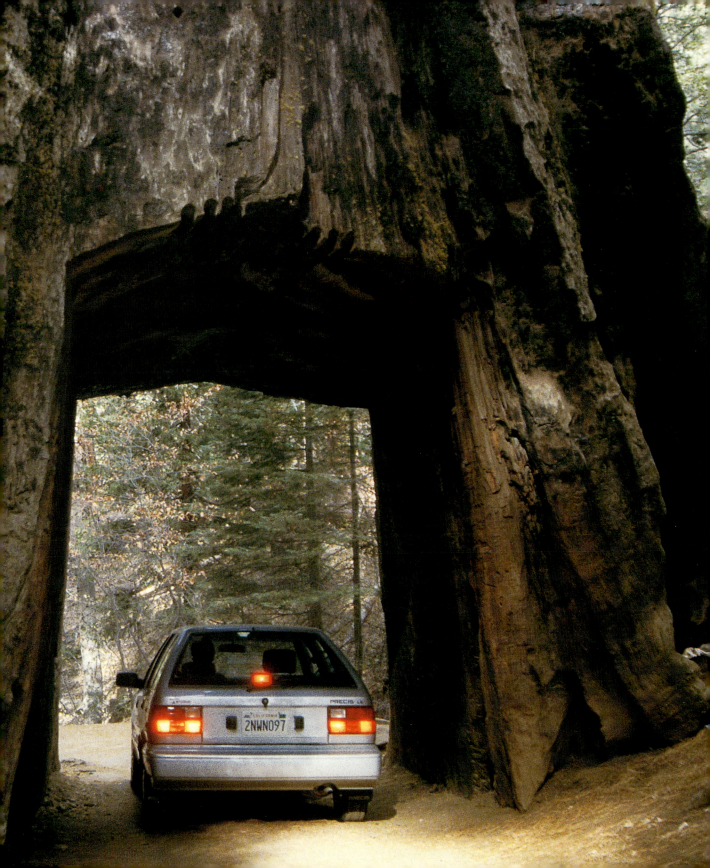

metres (a hundred to a hundred and thirty feet). The plane tree, which King Solomon is thought to have used to raise the columns of the temple at Jerusalem, also grows to an impressive age. In Chios in Greece the plane tree which provided shade for Hippocrates's medical consultations is said to be still standing, and so is the tree in Istanbul which sheltered the tent of the crusader Godefroy de Bouillon.

Hawthorns and yews complete the circle of the great trees of the old world. The hawthorns of St-Mars-sur-la-Futaie in the west of France were already thought to be ancient in the eleventh century. Numbered among the oldest yews in Normandy is one in the cemetery at Estry, which is sixteen hundred years old, and two in the cemetery of La-Haye-de Routot, which are fifteen hundred years of age. In Greece, the comparative rarity of these venerable plants can probably be explained by the fact that Alexander the Great decimated them for the bows and arrows he needed for his military campaigns.

Everywhere in the world, stories and legends are attached to special trees. Near Cairo, the old sycamore that stands within the ruins of Heliopolis could have witnessed the Holy Family's flight to Egypt, and might even be able to testify to the fact that it was Jesus who created the spring that flows nearby. In Cordoba, there is a palm tree which is said to have been planted as a memento of his native Syria by an Arab prince, Abd-er-Rahman, a contemporary of Charlemagne. On the slopes of Mount Etna, in Sicily, a three-thousand-year-old chestnut tree is thought to have sheltered Catherine of Aragon. In the state of Virginia at Muskettoe Point Farm on the Rappahannock River, the ancient mulberry trees are an ironic reminder of the pioneers' mistake, when, in their attempts to breed silkworms, they unwittingly grew the wrong species of tree for them to feed on. Their only success lay in planting the beauty of these wonderful trees.

Preceding pages: the monstrous dimensions of the Drive-Thru sequoia in California. *Opposite:* the bristlecone pines that grow in the White Mountains in the south west of the United States of America seem almost unimaginably ancient – they are five thousand years old and thought to be the oldest trees in the world.

50

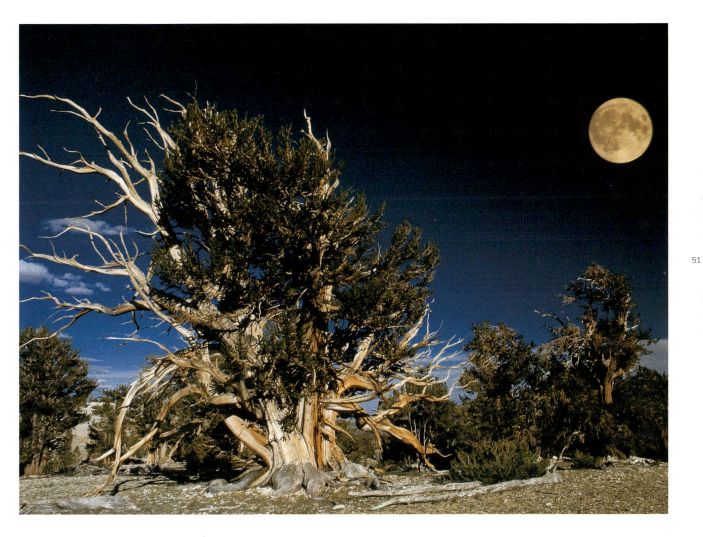

Many centuries ago, newly established religions tried to abolish pagan cults. Trees transcend the centuries, however; they are still close to us, and still symbolize death in the winter and rebirth in the spring. Older and stronger than human beings, trees present us with the eternal image of powers that are denied us. This is probably the reason why, at nightfall, south of Brussels or at least two hundred kilometres (well over a hundred miles) north of Paris, there are tree-lovers – very many to judge by the numerous tyre-marks – who go and tell some ancestral tree of an illness, a grief, a yearning desire, believing that it will take on all their sorrows. They believe in a power that may not spring from the tree's spirit or great age – a singular shape, a flaw in a trunk, a particular site, a past event may be enough to justify a mysterious, nocturnal ritual, to which only a few telltale signs bear witness.

RITUAL AND

In the fourth century AD, Arnobius, while travelling through Tunisia, described in his journal some magical trees covered in strips of cloth representing wishes. Over a thousand years later, in 1802, Vivant Denon recorded the same 'trees with offerings' in his book recounting his travels in Egypt, *Voyage dans la haute et basse Egypte*: 'There was one in Chendauyeh.... I found fastened to it by nails, locks of hair, teeth, small leather pouches and little banners.... The hair had been nailed there by women in order to fix their husbands' roving affections, and the teeth in supplication for a second set of teeth.' In 1929, two Belgian writers, Hermant and Bosmon, in their turn described the custom of tying objects to life-giving trees. In Oise, an archaeological account from 1854 lists two hundred and fifty-three trees, including fourteen linden trees, that were still honoured in the Department.

Cults do not deify the tree. It is not loved for itself, but is used as a vector or carrier through which various ills are transferred – a toothache, or maybe a skin condition, barrenness, madness, depression, love-sickness. One cannot touch the tree or the votive objects that are attached to it without exposing oneself to its power. When the trunk is crumbling under the weight of offerings, they must be burnt – this often kills the tree, but a new one is then immediately planted.

On the trunks of 'nail trees' or 'rag trees', the fantastic accumulation of ill-assorted objects resembles a jumble sale quite as much as it calls to mind a magical ceremony lit by the gilded glow of the sunset: pairs of tights, T-shirts, plasters, boxes of anti-depressants, pink corsets decorated with stars, pullovers, crutches, locks of hair entwined with rosaries, fresh or wilted bunches of flowers,

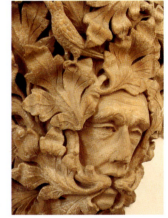

MAGICAL

rusty nails and coins seem to be eating away at the fibres of the trunk.

Since it could not suppress these cults, which were too old and too directly linked to great archaic myths, the Church – particularly the Roman Catholic Church – often raised crosses, chapels and oratories close by in order to reappropriate the faithful. Offertory boxes were erected on poles, with prayers pinned up under plastic. In the same spirit, the Jurbise oak south of Brussels became associated with the cult of St John, and the most famous linden trees were adorned with statues of the Virgin Mary – Our Lady of Deliverance, Our Lady of Grace, Our Lady of Consolation. In the sixteenth and seventeenth centuries, tall silver birch trees in Lithuania were decorated with multi-coloured figures of Christ carved into their wood, just as beautiful as those in the churches where only a few now remain.

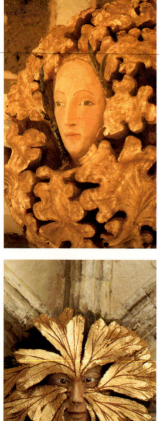

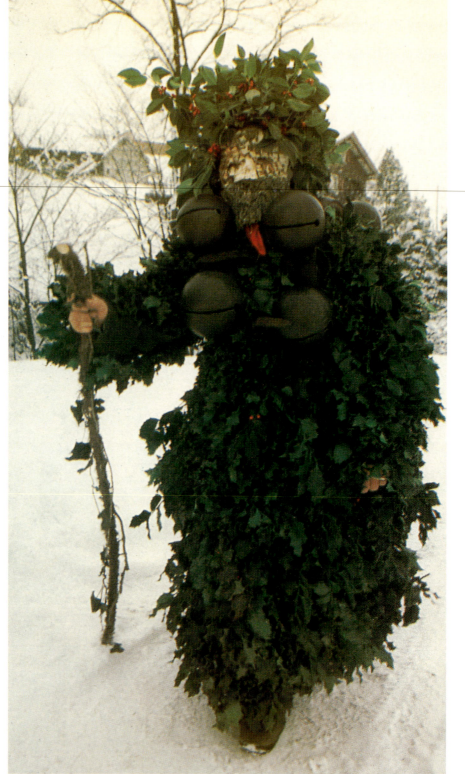

From Chartres to Fribourg, from
Dijon to Ulm, many of the great
central and northern European
Gothic edifices have images of
the Green Man, or *feuillu*, symbol
of death and rebirth. Twigs and
leaves sprout from their mouths,
and in the springtime they are
decorated with green branches.
Preceding page: Sutton Benger
church in Wiltshire, *c.* 1300;
opposite, above left: Exeter
cathedral, *c.* 1310; *below left:* the
cloisters of Norwich cathedral,
1415; *opposite, right:* the people
of Appenzell in Switzerland cover
themselves with branches, bark
and leaves on New Year's Eve;
right: Green Man in Bamberg
cathedral, Germany, *c.* 1200.

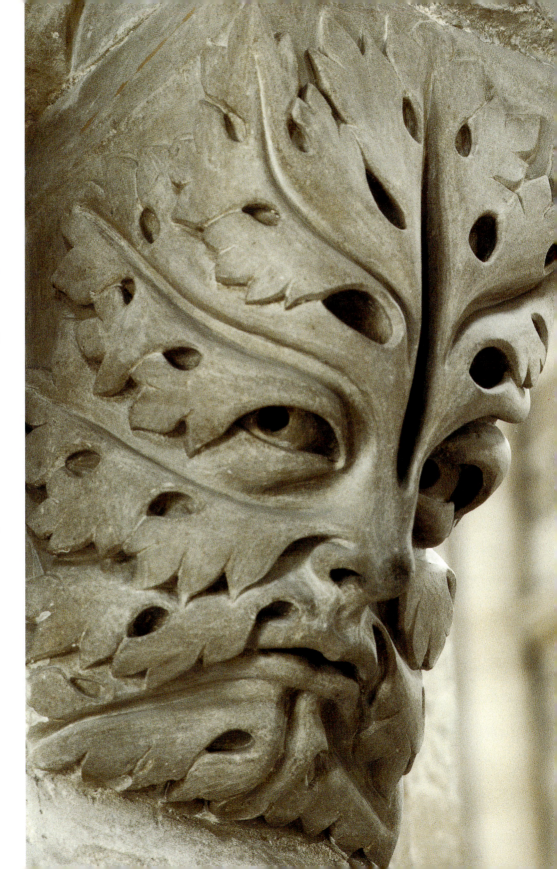

Den 29. Ianuary 1633. feindt bey
Hefingen, einftundt von Bafel, 48
bauren wegen einer auffruhr an
drey bauwm gehenckt worden.
Supplice de 48 Payfans pres Hefingen
29 janv. 1633.

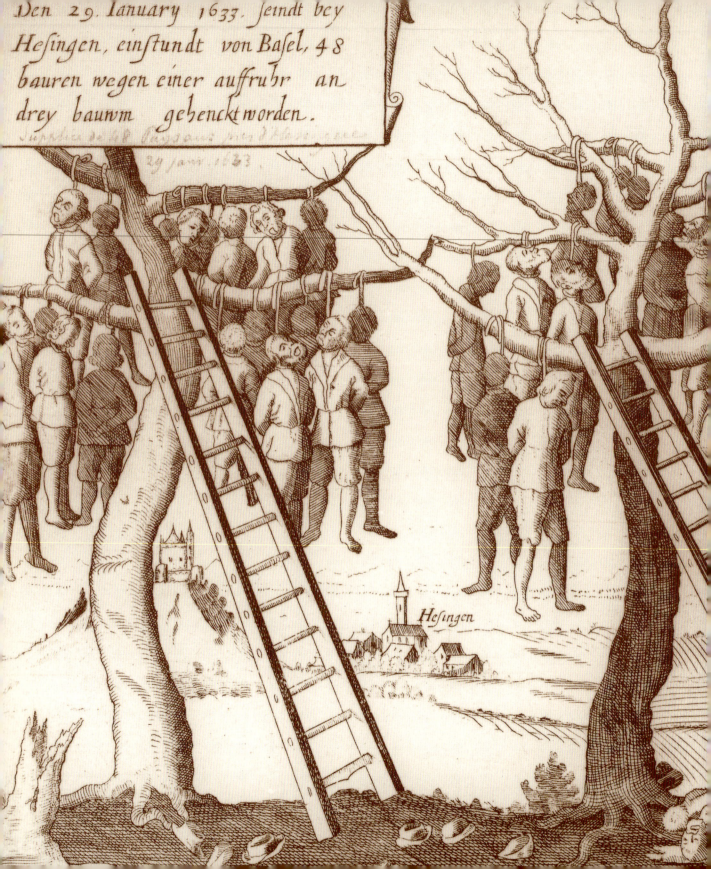

Hefingen

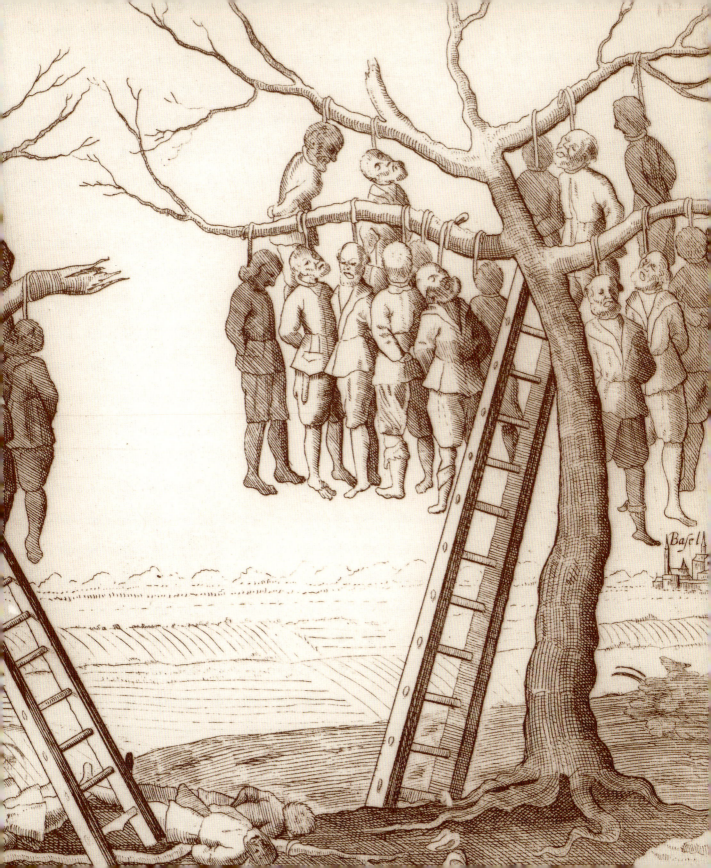

Catholic Europe is accustomed to the idea of pilgrimages to certain remarkable trees, particularly on Ascension Day or on 15 August, the Feast of the Assumption of the Virgin Mary. On the last Sunday in April, people gather around the elms of Senarpont. In Teillay, in Brittany, there is an oak at a place known as 'La-Tombe-à-la-Fille' (the Girl's Grave), where a young shepherdess was hanged, wrongly accused of treason during the royalist uprising of 1793 in the west of France, known as the Chouan war. As late as the 1960s, the powerful aura of the place was thought to cure diseases of the foot and leg. The ankle-boots, false legs and socks that were

left testified to this. Today, the most diverse objects and clothes and sometimes even money can still be found there.

In India, women go to the foot of the banyan tree, whose aerial roots recall the Cosmic Tree, to lay offerings which will ensure them male children. In California, offerings are placed in the hollow of a pine; and a certain variety of ficus – very similar to the banyan tree of India – is at the centre of rites held by the Mexican Indians.

Sometimes the tree exerts its power merely by existing. It may be enough to expose a child under its branches or between the two halves of its split trunk, to drink the rain which splashes on its bark or to keep its fruit about one's person. So-called magic chestnuts are exhibited at the Arlaten Museum in Arles: old people still ward off bad luck by placing them deep in their pockets.

In La Margeride, a remote region of the Auvergne, trees play a part in marriage rites: people go up to the mountains at dawn to cut down a juniper tree, which is then decorated with paper flowers for good luck and attached to the bridal couple's house. It was believed in many places in Europe that a juniper tree burned inside a house would disinfect it and protect it against epidemics; like the hawthorn or the elder in

other regions, it also had the power to drive away evil spirits; some branches are still found above the doors of houses. A linden tree called The Lovers' Tree in the village square in Lucheux, in the north of France, invites newly weds to walk through its double trunk. On their wedding-day, dozens of couples enact this lucky ritual; it is said that the first to thread his or her way through will wear the trousers in the marriage. In Bengal, couples are tied to a mango tree during the actual marriage ceremony so that they may benefit from its influence.

The ancient yew trees of La Haye-de-Routot in Normandy (they are more than fifteen hundred years old) were witnesses to an even more spectacular ritual: the St-Clair fire. Every year on 16 July, since the ninth century, people have erected a tall trapezium-shaped pyre beside these two giant trees; the burnt branches protect houses from lightning and the fire is said to cure eye disease. This festival is strangely reminiscent of the pagan ceremony of the 'Lucariana' celebrated by Druids at the new summer moon in several sacred woods in Normandy.

Not far from there, in Vieux-Port, a most ancient secret rite takes place by night; it consists of knotting the branches of hazel trees around the old spring of St Thomas, whose waters were said to cure leprosy. In the seventeenth-century story by Giambattista Basile, a first version of *Cinderella*, the unfortunate princess begged a branch of the hazel tree from her father. Once planted on her mother's grave, the hazel branch would make all her wishes come true. The hazel tree is the magical plant from which water-diviners and metal-diviners cut their rods; the fairy's magic wand is also made from hazel – mortals who find one of these wands can use it to rid themselves of the devil.

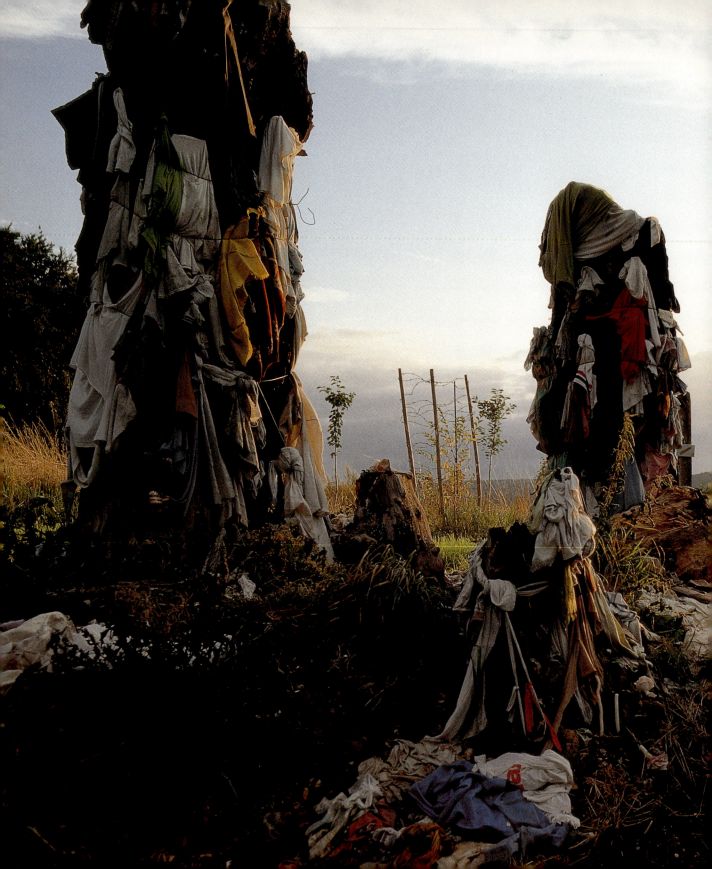

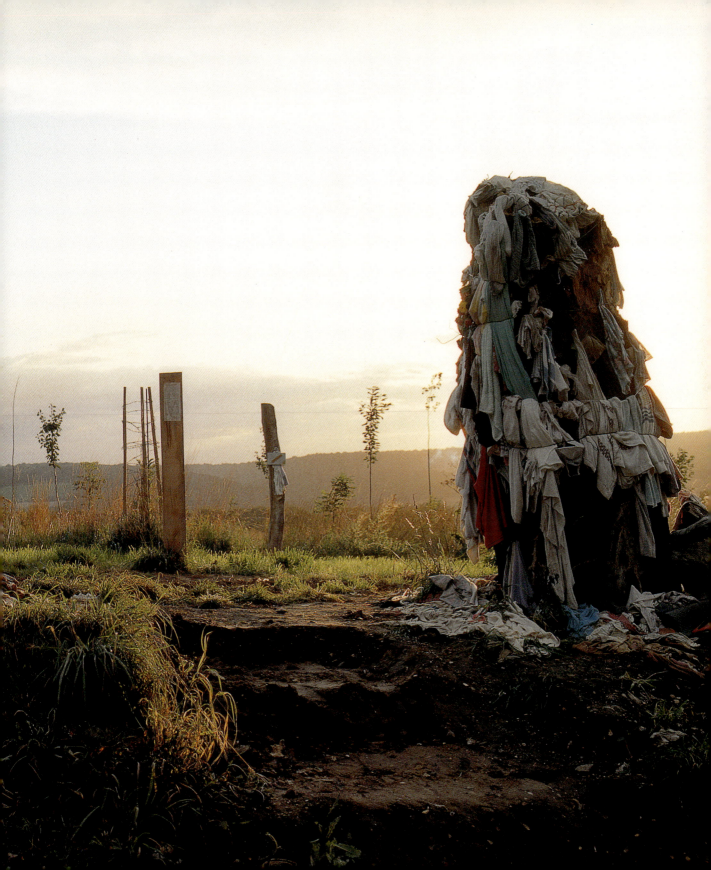

Preceding double page, and below and right: in the fifteenth century, the Black Death stopped at the elms of Senarpont, between Paris and Le Touquet. Since then, people have fixed offerings to their trunks, which are now scarred by fire. They come to hang 'rags', which act as intermediaries, and slippers for rheumatism, shirts for lungs, scarves for the throat, crutches, boots and false limbs of all sorts. If the wish is granted, flowers are placed there in gratitude for the good fortune.

Opposite, top: in England rags and ribbons commemorate the death of the pop star Marc Bolan on this road. *Centre:* in Brittany, the oak at La-Tombe-à-la-Fille (the Girl's Grave) cures leg and foot injuries. If anyone should ever dare to try to cut it down, he would see 'the axe turn on him'. *Below:* a thousand tiny flags recall the marriage of two Shropshire lovers that took place here two hundred years ago.

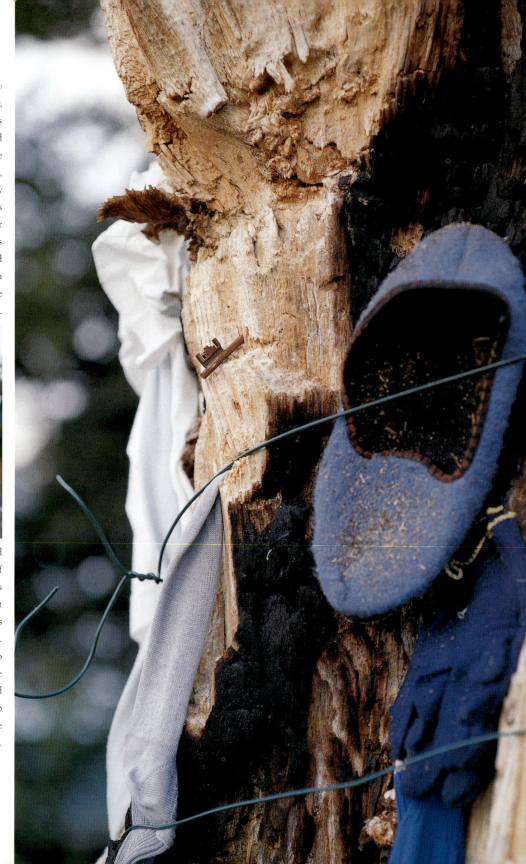

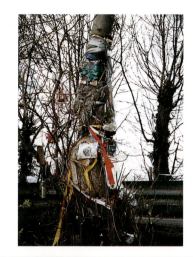

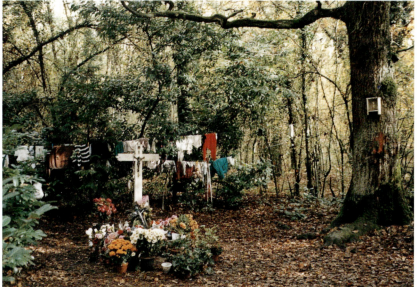

63

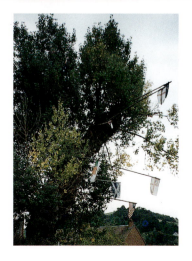

In Europe the first day of May is still the occasion of many festivals and ceremonies associated with branches, trunks and trees that are evergreen. At the time of the spring equinox, the Romans used to celebrate the pine tree, which the priests would bring back from the forest, freshly cut down, wrapped up in bandages like a corpse and adorned with violets – the image of a dead winter! Amid the din of cymbals, drums, horns and flutes, the priests would cut their arms, shedding their blood on the tree. The crowd would go into a trance, and some might even castrate themselves. This fertility rite was to bring about the rebirth of plant life.

Still surviving today are less picturesque and less barbaric rites celebrating the renewal of life with the coming of spring. The symbol of life and death, the Green Man, was masked by leaves that sprouted from his mouth and nostrils, as he can still be seen in medieval carvings in the cathedrals of Norwich and Exeter in England, and in the cathedrals of Auxerre, Poitiers and Chartres in France.

In Switzerland, Africa, New England and Australia, people dress up in springtime as wild men of the woods or as trees, or they may dance around the maypole, a simple totem or a trunk that has been fixed upright and decorated with ribbons. Some attempt to reach the top of that 'greasy pole', determined to claim the reward which, although always a symbol of heaven (as with the shamans of Siberia), might perhaps be nothing more than a bottle of good wine.

At Hallowe'en the people of New England in the United States erect trees outside their front doors which they hang with plastic bags representing tiny sprites. These are no doubt related to those spirits which the inhabitants of Trinidad hold in such dread when they see them materialize as 'beards' hanging down from silk cotton trees. In Brittany, not so long ago, people still went about their daily business in the company of pixies, gnomes and korrigans, who lived in tree-trunks. Those who were born with the century have 'seen' them.

During his visit to Egypt in 1802, Vivant Denon discovered a tree hung all over with little leather pouches, pieces of cloth, locks of hair and metal nails. He made a drawing of the tree.

65

The very sap and flowers of trees also 'speak' to us. Legend has it that the national emblem of Argentina – the red flower of the ceibo, or coral tree – appeared when the conquistadores tied a young Indian girl called Anahi to a tree to burn her alive; the tree at that moment suddenly blossomed with blood-red petals. As for the almond trees of Andalusia, they only flower in the middle of winter, forming spotless sheets of white to commemorate the love of a Moorish sultan who hoped to soothe his Norse wife's aching nostalgia for the dazzling white snows of the fjords of her homeland.

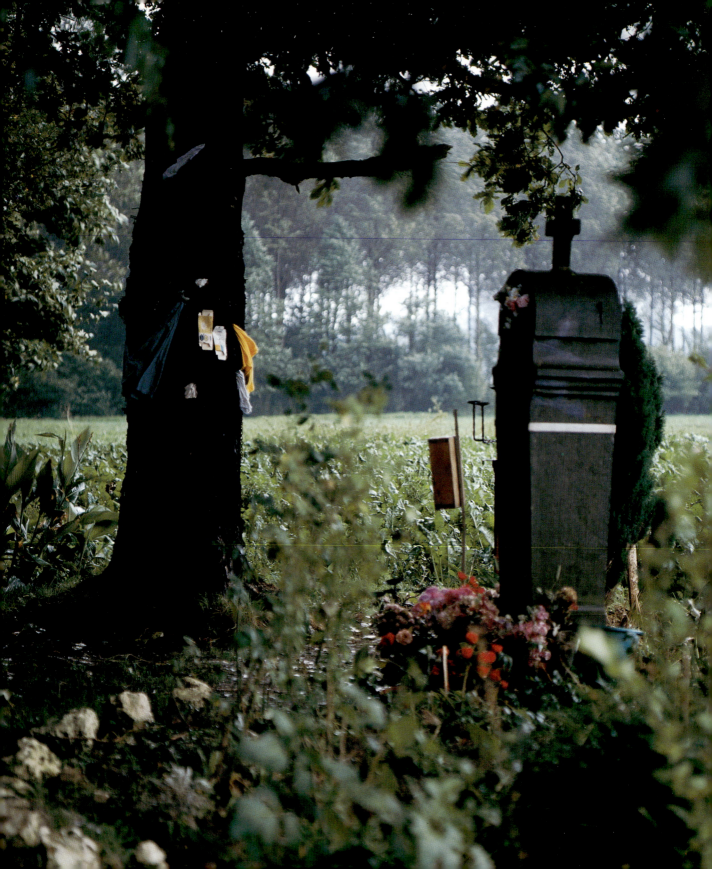

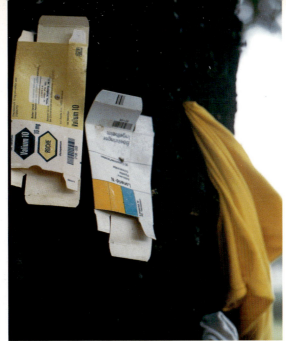

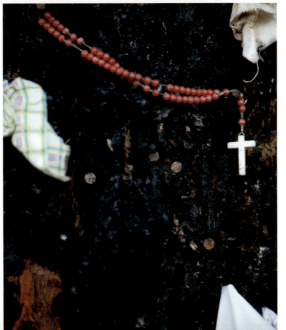

In the middle of a field south of Brussels, the Jurbise oak, the 'Oak of Nails', has been known since the Middle Ages. The Catholic Church rechristened it St Anthony's Oak. At night people come to hang clothes, medicine packets, rosaries and bandages on its trunk. When there are too many offerings, these are burnt, which kills the tree, but a replacement is then immediately planted.

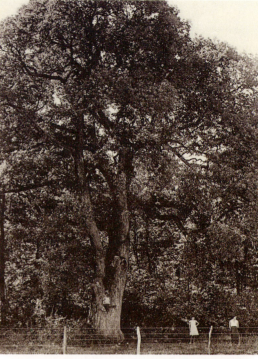

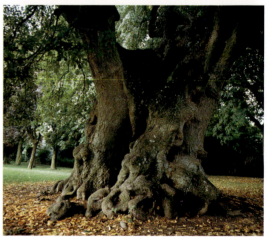

Opposite, above left: in Paris, the elm of St Gervais, a former Justice Tree, is now only used by white witches. *Below left:* newly weds of La Margeride mark their house with a decorated juniper tree. At Lucheux, *below right*, they pass through the trunk of a linden tree, a tree of happiness like the Blessed Oak at Magny-les-Jussy, Haute Saône, *above right*, which is at least a thousand years old.

Left: weaving a spell – at Vieux-Port in Normandy, near the old lepers' spring, a knot has been tied in a hazel twig; fairy wands are also supposed to be made from hazel.

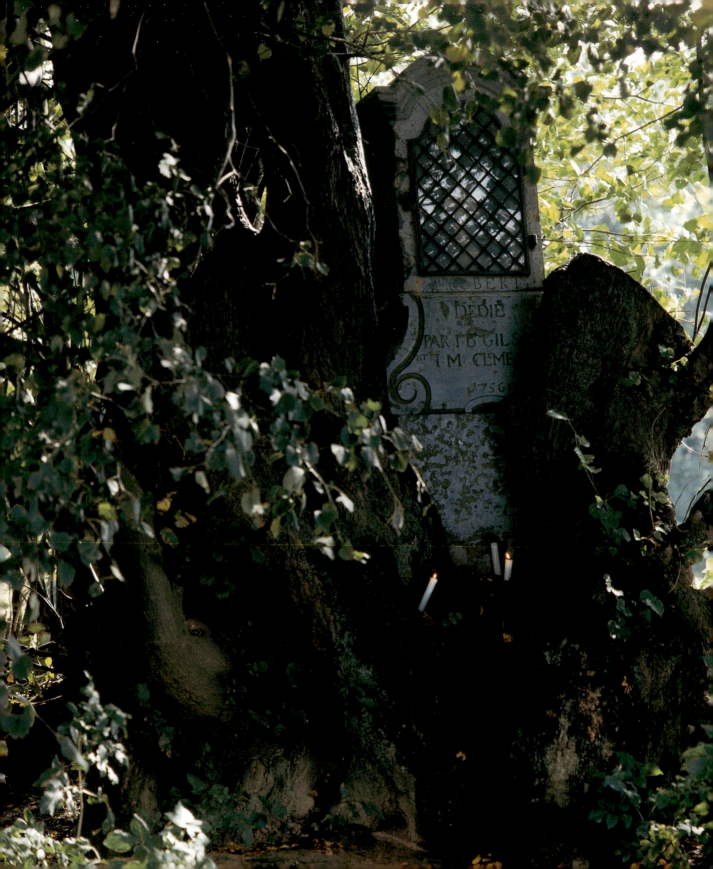

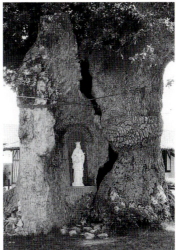

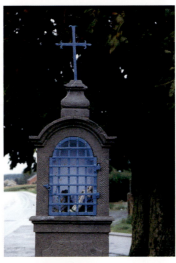

Opposite: Christians built the chapel of St Robert in the famous linden tree of Lasne in Belgium in 1756, in memory of a young shepherd who died in the area. Are the candles there to invoke the tree or the saint? *Left, top:* at Dax, Our Lady of Lourdes has nothing to do with the oak in which she is hidden. This eight-hundred-year-old tree has been dedicated for some centuries to the cult of St Vincent de Paul, who, it is said,was born close to it in the sixteenth century. *Centre and below:* in Flanders and Holland old trees with pagan associations have been taken over by the Church.

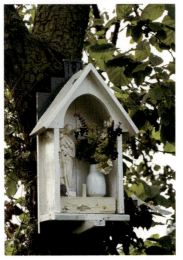

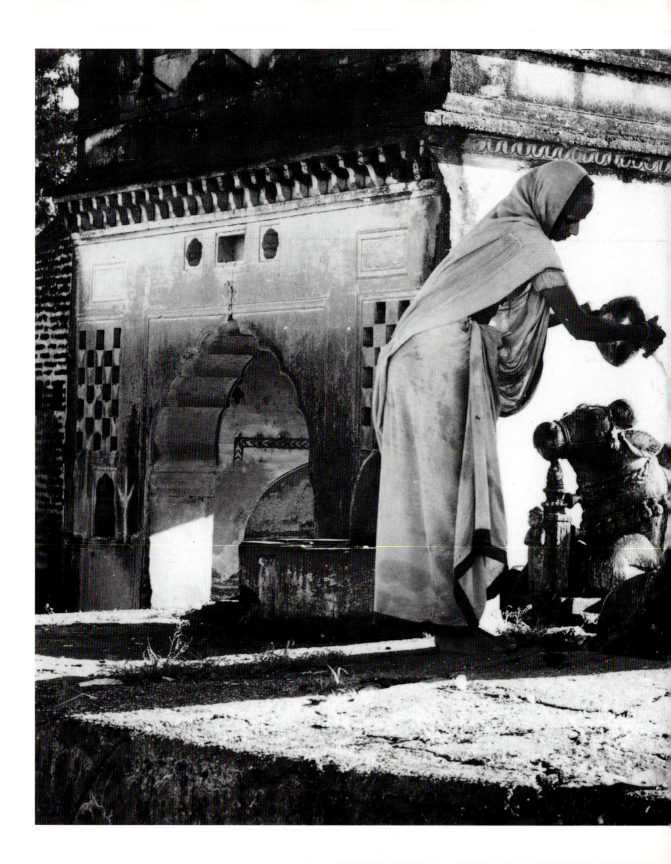

72

In India, watering the foot of the banyan tree and placing offerings there in the form of stones is supposed to bring happiness and especially fertility.

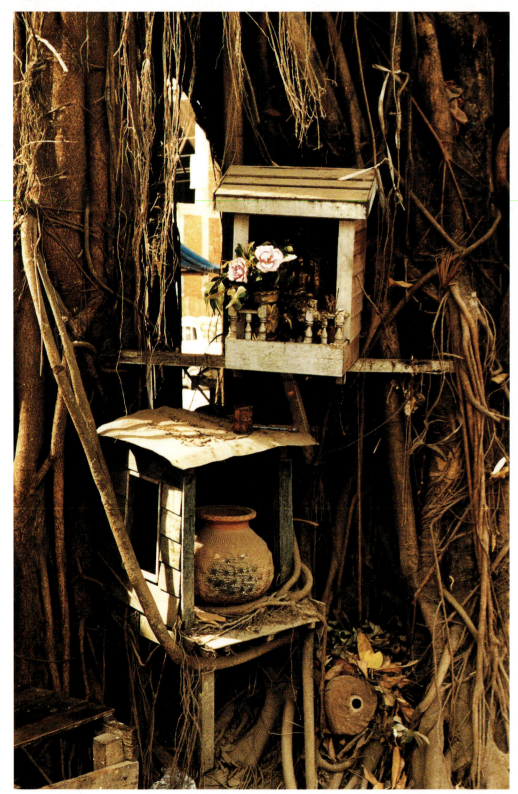

Below: this ficus in Mexico shelters a statue of Christ surrounded by candles and paper flowers.
Left: in Burma, flowers, vases and other offerings are presented in delightful little houses, altogether

different from the old rags and rusty nails found in Europe, even if the goal is the same: to talk to the tree.
Opposite: in Thailand, appeals are made to Buddha; here his image is attached to a tree trunk.

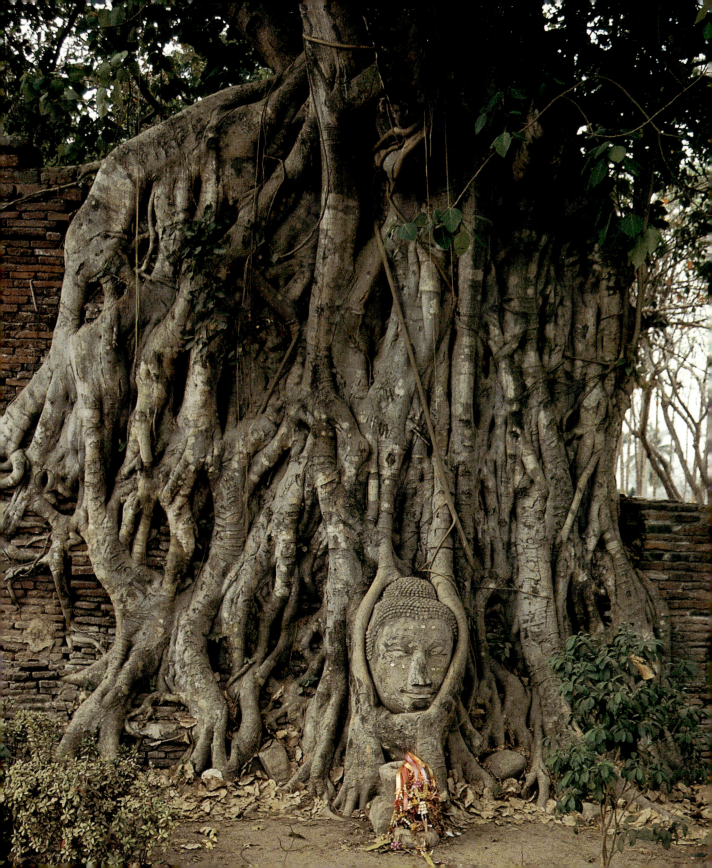

ature gave some tree species the most baroque, extravagant or unexpected shapes, but man has gone even further, seeking to mould the trees around him to his own fancy: from bonzai to topiary, man has tried to reinvent nature.

The art of topiary consists of trimming or forcing trees or shrubs by contorting them, lacing them with wire or weighing them down in order to obtain singular shapes, creations that are not part of nature's repertoire. The Romans knew this technique as early as the first century AD; a friend of the Emperor Augustus, Cnaeus Martius, alludes to it, and, a century later, Pliny describes hedges trimmed to look like animals, obelisks and 'letters forming the name of the master of the house'. And yet it was not until the Italian Renaissance that topiary became fashionable again. In the sixteenth century, on his journey to 'the peninsula' (Italy), Montaigne described rapturously

SINGULAR AND

'those boxwood trees spreading their branches in a circle, so dense and artfully trimmed that they seem like highly polished balls'. Similarly, in 1499 the erudite Francesco Colonna imagined extraordinary topiaries in his famous *Hypnerotomachia Poliphili (The Dream of Poliphilus)* which describes a sort of initiation-quest through a series of palaces, temples and marvellous gardens.

From Italy the fashion for topiary moved to France. Created by Le Breton in the sixteenth century and restored between the First and Second World Wars, the gardens of Villandry are the perfect illustration of this art of 'embroidery'. At Vaux-le-Vicomte, St-Cloud, Marly, Versailles (though in a much more sober manner), Le Vau and Le Nôtre punctuated their flowerbeds with small cones of black yew, or surrounded them with

mile-long ribbons of box, as well as hedges of hornbeam. Meticulously pruned to create closed bowers, dark and impenetrable screens, they suggest order and geometry, although their purpose is to conceal the most extravagant entertainments. The Dutch, who were constrained by space and wind, would create tiny, complicated topiaries of painterly perfection. In England, it was only in the reign of William and Mary in the seventeenth century that this fashion took hold, blending French and Dutch tastes for box, holly and yew. Probably planted as early as the sixteenth century, the enormous rippling yew hedge at Montacute in Somerset has stood the test of time. That at Blickling Hall in Norfolk is over ninety metres (three hundred feet) long. But the best examples of the period are to be found at Knighthayes in Devon, Packwood House in Warwickshire and

MISSHAPEN

Levens Hall in Cumbria. The garden of Levens Hall, planted between 1690 and 1720 by Guillaume Beaumont, boasts yew-tree sculptures over eight metres (twenty-five feet) tall, which took three months to trim. Never before or since have topiary figures been more fanciful. Chessboards, Celtic harps, Noah's arks and hunting scenes were skilfully created. The image of Christ and his apostles was particularly popular.

The eighteenth century of Capability Brown was inflexible: these 'vegetable aberrations' were sheer provocation to philosophers, botanists and landscape gardeners who were captivated by 'the natural'. However, the fashion for topiary reappeared in the nineteenth century around English cottages, where it is still practised with the same fervour, and on the great elegant estates of the American east coast, like Monkton in Maryland, in a register more picturesque and amusing than grandiose.

Applying torsions and curves to the branches of fruit trees, La Quintinie, Louis XIV's gardener, revived the techniques of the Renaissance (as can also be seen today in the garden of the Orsan priory in Berry) and created an ambitious vegetable garden at Versailles which had many imitators. To ensure that the fruit would be protected and would mature earlier and more abundantly he favoured the espalier, producing complex geometries that might give the impression, mistakenly, that they were created for sheer visual effect. It was indeed for mere aesthetic pleasure that the branches of the robinia and the linden tree were grafted or knitted together, creating covered walks and strange figures, such as the three-tiered tree, the linden at Momignies in Belgium, which has been compared to a five-hundred-year-old 'curly-haired poodle'. On the other hand, the branches of the plane trees of Provence are disciplined for a purpose – to create more shade from the fierce summer sun.

The Chinese, and later the Japanese, wished to reduce natural irregularities to a miniature scale: thus the bonzai was born, a tree that is kept to a hundredth of its natural size through a slow series of very expert bud-pinchings and root-trimmings, sometimes employing wiring. The Emperor Hirohito owned a veritable miniature forest containing plants ranging from hundred-year-old elms and maples to the most fantastically shaped fig trees.

And yet, left to its own devices, nature produces results that are just as spectacular. When pollarded close to the ground, a tree may develop up to seven trunks or more, like the oak at Villers-Cotterets in Normandy known as Les Quatorze Frères (The Fourteen Brothers). It is said that the hollow or 'vat' between the trunks contains a healing humus. When planted too close, an oak and a beech will grow in the same direction, and may become joined to form a two-headed hydra of disquietingly

Page 77: in Belgium, a topiary ring in boxwood similar to that in the *Dream of Poliphilus,* by Francesco Colonna *(page 76). Preceding double page:* a chestnut tree in Flanders, altered in shape by lightning. *Left:* in the Gambia, a mangrove growing around the trunk of a palm tree. *Right:* another mangrove in the Galapagos Islands grasps the stones sunk in the mud. *Overleaf:* twisted beeches of Faux de Verzy, near Rheims.

80

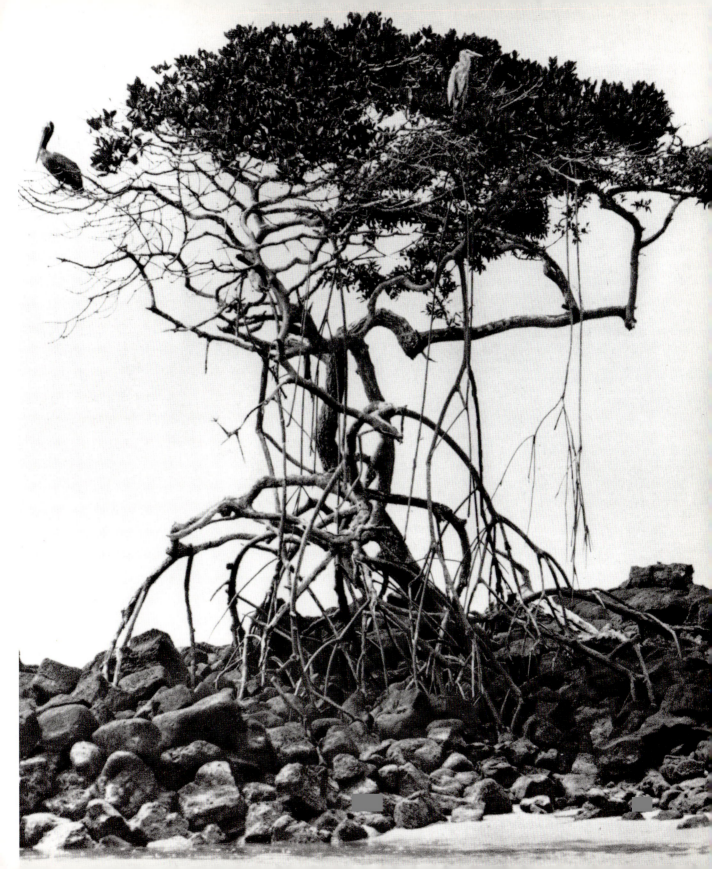

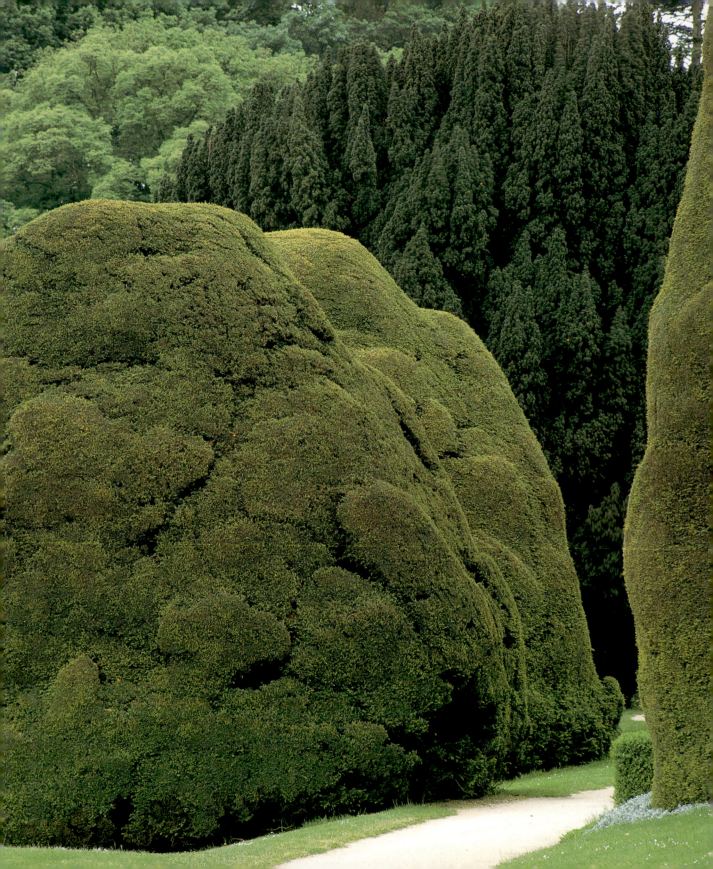

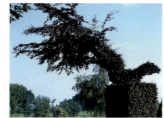

hybrid foliage and fruit, as happened, for instance, in the case of the Bonne Entente in northern France. As for the trunk, a single wound or virus will create hollows, lips, furrows and knobs. The diseased fruit of the citrus tree takes on such unexpected shapes that some are displayed, with other wonders, in Louis XIV's *cabinet des curiosités* at Versailles.

Roots can be remarkable, too: those of the bald cypress trees of Louisiana spring up out of the soil, those of the African kapok tree form sculpted and rippling cones, the aerial roots of the banyan tree turn into a strange sculpture or an inextricably tangled ball of thread; and yet there is nothing more 'natural'. Constrained by the excesses of its climate, a whole tree will shrivel and crouch in an extreme distortion. In Brittany

Left: at Powis Castle in Wales the yews resemble great beasts. *Above right:* cutting a topiary bird in Holland; *below right:* an elephant cut out of yew in Portsmouth, Rhode Island. *Overleaf:* the yews at Levens Hall in Cumbria, still there today, were planted in the seventeenth century by Guillaume Beaumont; here they are illustrated in a nineteenth-century engraving.

and Devon, a pine or sloe shaped by the west wind may grow practically horizontally. In Africa, as a protection against drought, some trees have trunks that swell enormously, like the surreal bottle-tree, or the obese baobab which is so spongy that an elephant can fell it with a kick.

The composition of the soil may keep a tree to midget proportions, like the Californian pygmy cypress, which only grows a metre (three feet) every two hundred years; or, conversely, may make it a giant, like the Roscoff fig tree which spread over six hundred square metres (six and a half thousand square feet) and eventually had to be cut down since each branch was growing at the rate of seventy-five centimetres (two and a half feet) a year. In France, the strangest natural site is undoubtedly the wood of twisted beeches known as Faux de Verzy, near Rheims, whose unsettling and elaborate shapes, famous since the sixth century, have never ceased to fascinate botanists. They look like something out of a fairy tale that has been given the Disney treatment with the sole intention of enchanting us.

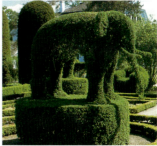

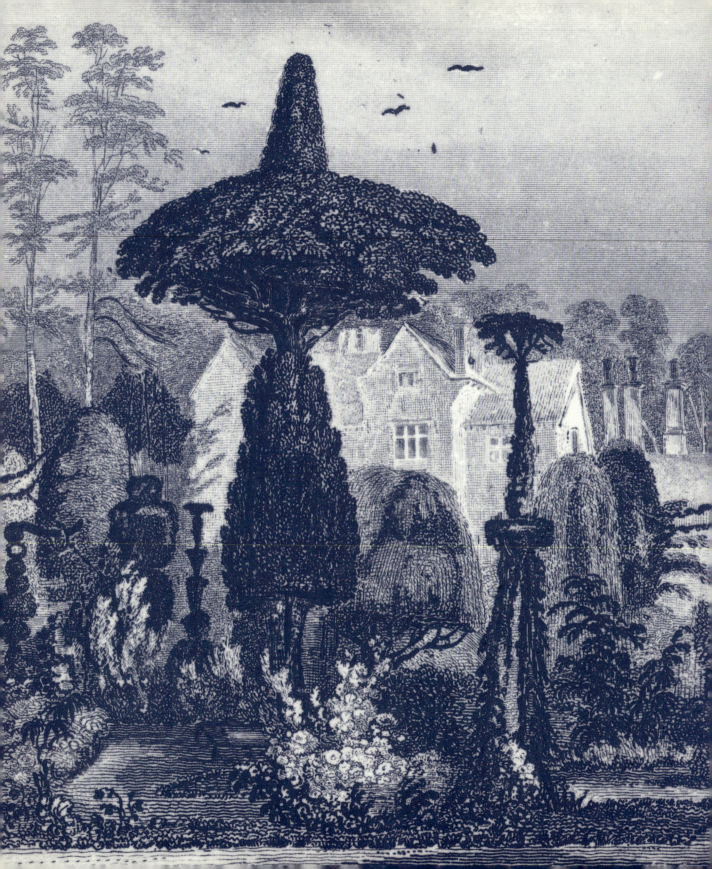

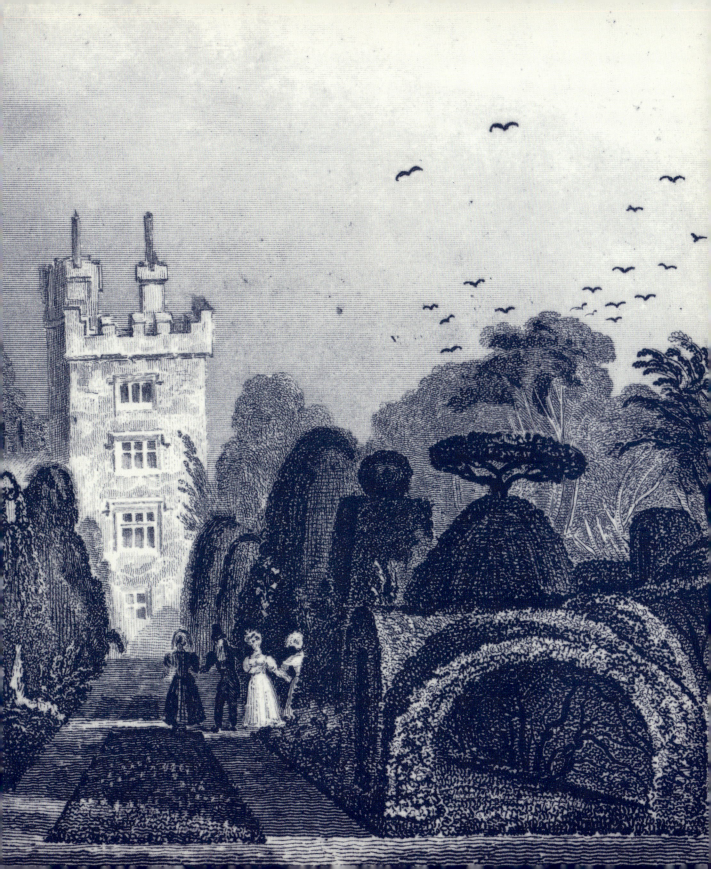

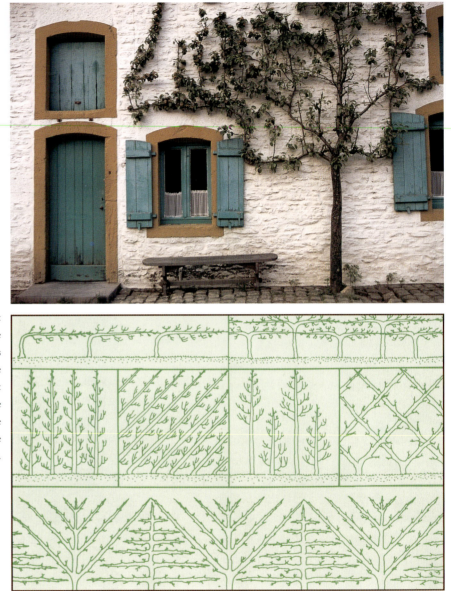

Above right: in Belgium, a modest pear tree is enough to change the appearance of a façade. *Right:* Louis XIV took great pride in the espaliered fruit trees in his great vegetable garden at Versailles. The art was invented during the Renaissance to increase the quantity and quality of the fruit.

Below left: in central France, a wisteria, planted while the house was being built, is now threatening to invade it. *Below:* a rhododendron in the Himalayas looks like a tree. We shall never know whether the extravagant botanical plans shown on these pages from *The Dream of Poliphilus (opposite, top left)* and the project for the ducal castle of Brunswick, *(left)*, were realized. However, we know that the west wind sculpted this sloe tree on Bodmin Moor in Cornwall *(overleaf)*.

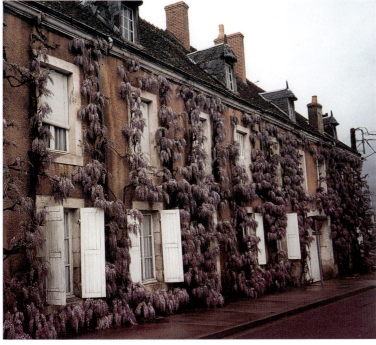

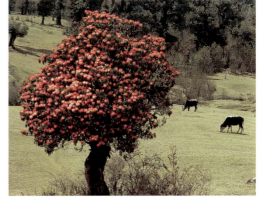

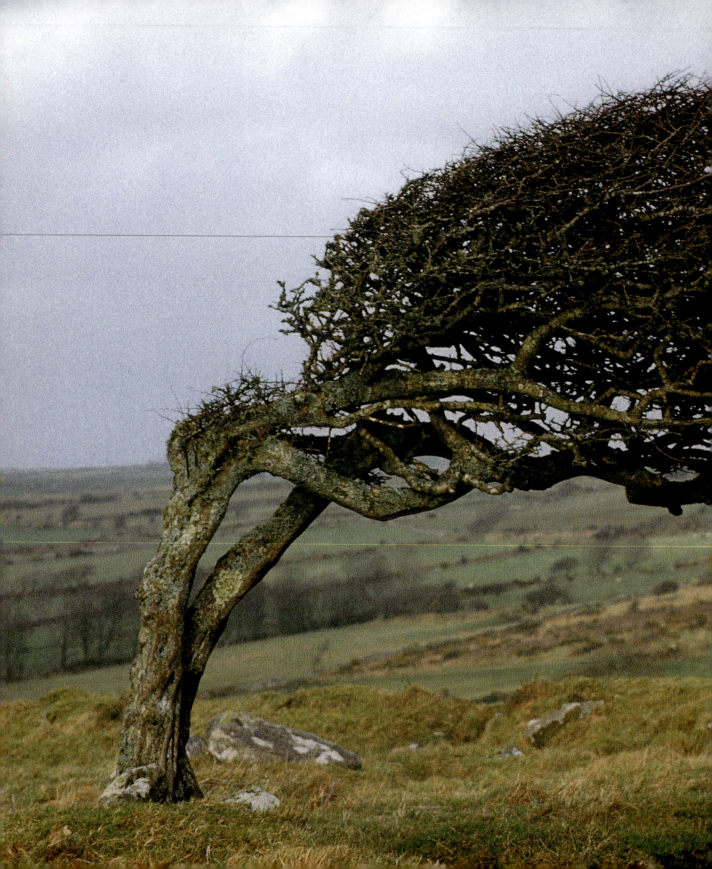

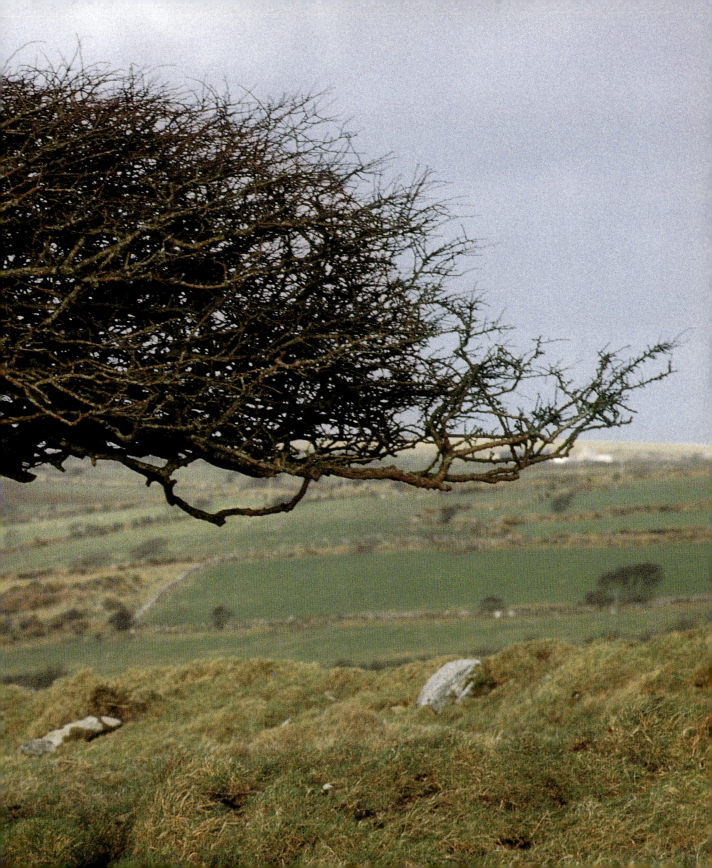

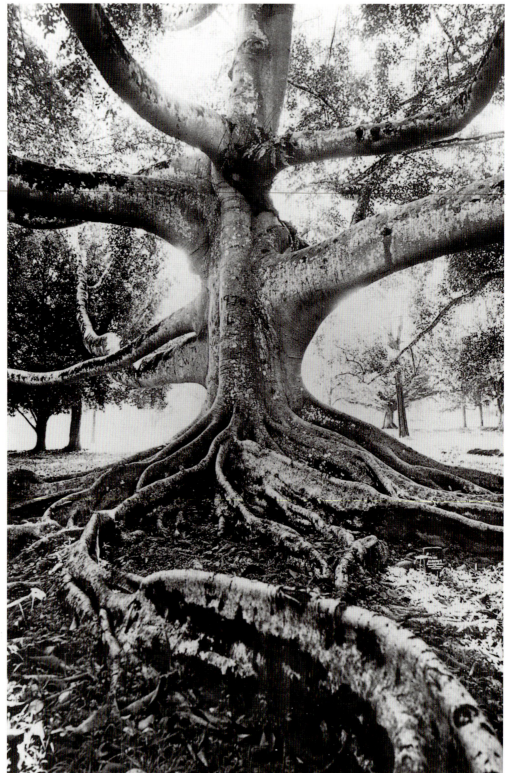

Opposite: like an octopus, the roots of the strangling fig imprison the twelfth-century Khmer temple of Angkor in Cambodia and *(right)* carpet the earth in Sri Lanka.

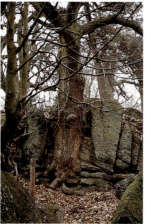

Above: this beech in Wales engulfs blocks of granite with its roots. *Overleaf:* in France, the lords of the château of Outrelaise lined up their plane trees, newly imported to France, with great precision. They dreamed of a straight avenue, but nature decided otherwise: today the trees that they planted spread in all directions.

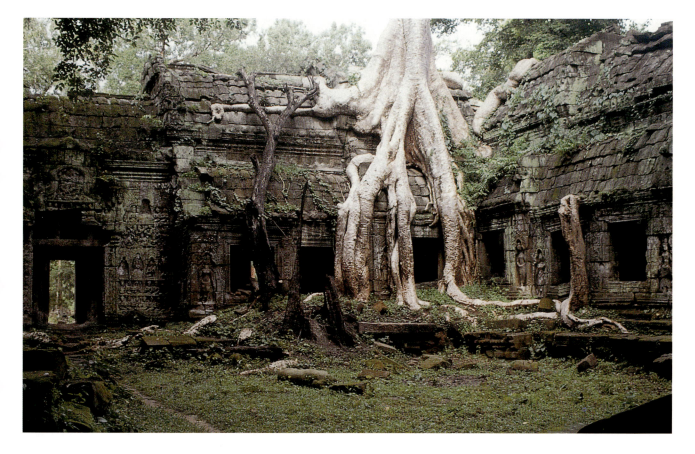

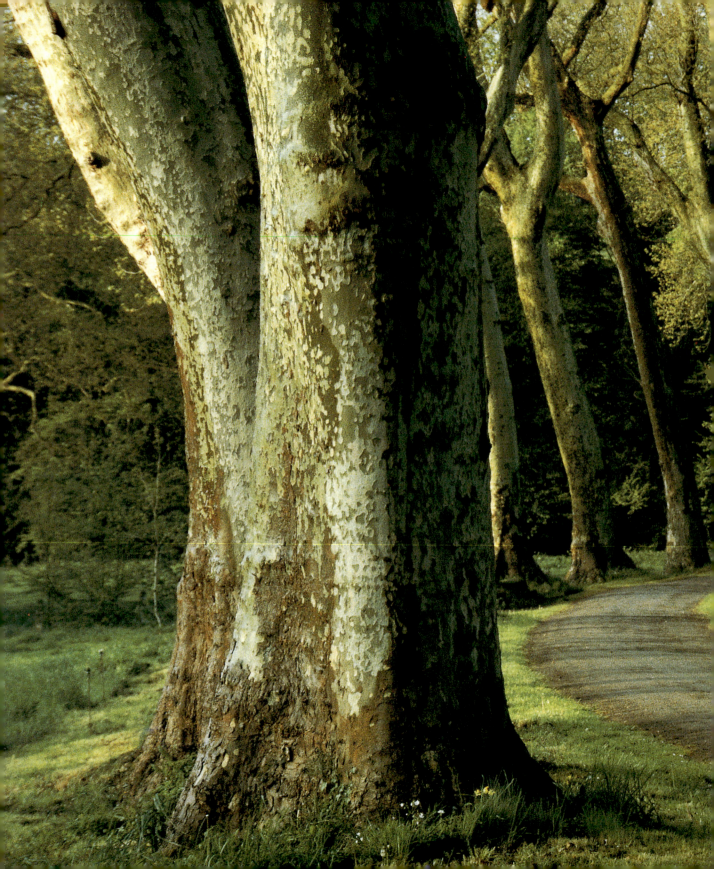

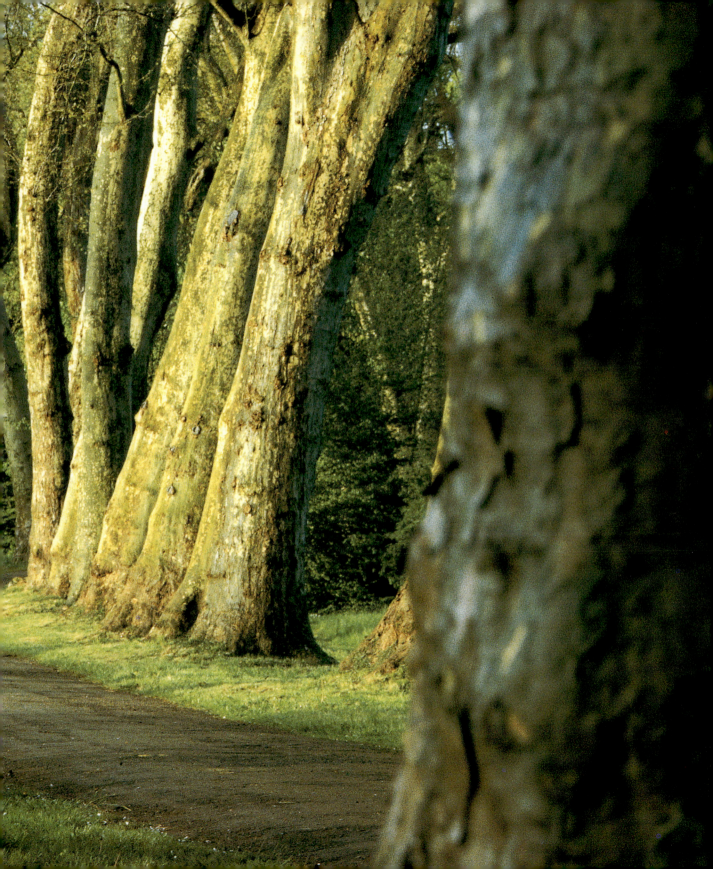

With its branches, its hollow trunk, its sheltering leaves, the tree, from prehistory to the present day, has always been put to practical use. In New Guinea, in islands of the South Pacific, on the banks of the Orinoco, whole tribes still live in trees to protect themselves from animals and floods: tree houses are to humid, hot countries what caves are to cold ones. In films and stories, this utopian, nostalgic way of life is made to seem very romantic. Like Tarzan, Zephir the monkey in the Babar stories and Christopher Robin's friend Owl live high up in trees, while Beatrix Potter's characters, like the pixies, prefer roots, trunks, the natural shelters of nests and hives and the places where the forest-dwellers hide their food.

Another age-old function of the tree has been as a meeting-place. We have the 'palaver trees' in Africa and justice trees on European village squares, like the

DOMESTICATED AN

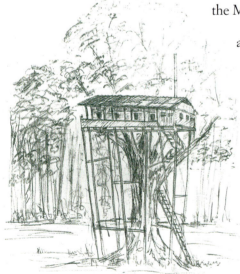

so-called St Louis oak in the Vincennes forest. In the Middle Ages, there would be a stone close to certain trees, such as the Linden of the Tithepayers' Cross in the Marne, where people used to place their tithes. The stone also played a role in grimmer rituals: people came here to identify dead bodies, and coffins were laid on the stone on the way to the cemetery. Justice trees served as gallows in wartime; and wolves were also hanged from them – there is a tree called the Wolves' Oak at Condé-sur-Risle in central France, where this was the custom.

It is in the shade of certain baobabs or mangroves that Africans or Papuans shelter their dead.

In the countryside single trees are used as boundary markers or landmarks. They marked out the way followed by the pilgrims to Santiago de Compostela. Seen from the ocean, a tree will help the sailor navigate straits or avoid rocks; on a plain it indicates a territorial frontier or a rallying post (such is the case with the Partisans' Oak in St-Ouen-les-Parey in the Vosges). A tree may also serve to signal a place of sanctuary, like the umbrella oaks of Protestant houses in the Tarn. When it towers over an area, it becomes a strategic observation point. In the desert it indicates a watering hole (like the tree at Ténéré, no longer standing – planted beyond Agadez, it was supposed to represent the 'ends of the earth'). Such symbolic trees appear frequently in the Old Testament. In the Book of Daniel,

D CIVILIZED

in the dream of Nebuchadnezzar, it is referred to as a 'single tree' or 'dry tree'. For Marco Polo it took the form of a plane tree standing on the frontiers of Persia at the end of an eight-day walk: 'It is very tall and very large, with green leaves on one side and white ones on the other.... It is said that this was the site of a battle between Alexander the Great, king of Macedonia, and Darius, king of Persia.' In the universal imagination these trees mark out the limits of an unknown realm destined to be conquered and dominated. That is where the Other, the one who may annihilate you, will come from.

Other civilizations, other eras: some only ever saw the tree as an object of pleasure. The Japanese built bamboo platforms in Kyoto at the height of a bird's flight.

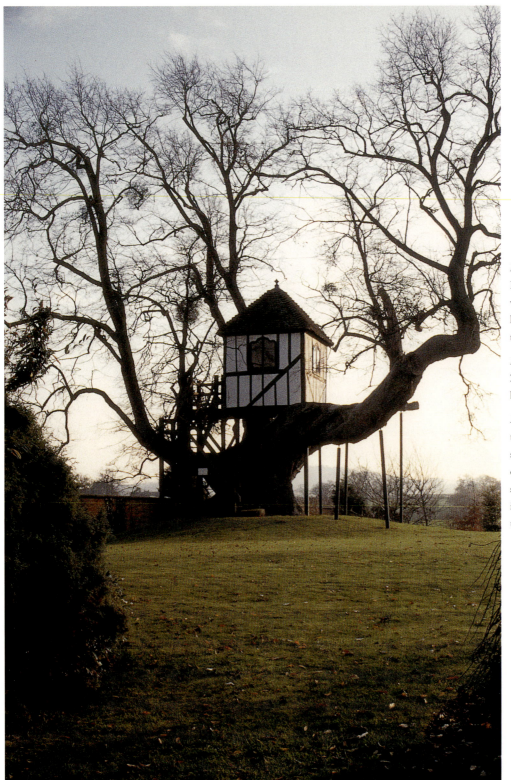

Page 96: The Tree Tops Hotel in Kenya, where Princess Elizabeth was staying on the day she heard that she had succeeded to the British throne.

Page 97: The house belonging to Zephir the monkey, Babar's friend, by Jean de Brunhoff, 1936.

Left: In Shropshire, this linden tree and its small Elizabethan summer house *(opposite)*, with its eighteenth-century stucco, sheltered more than one queen, including Queen Victoria who used it as a look-out for foxes.

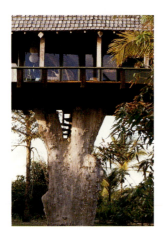

From these platforms, they would observe the moon or the russet leaves of autumn. The Persians imagined gold and silver staircases leading up to drawing rooms, open to the cool evening breeze, where they could recline languidly on silk-velvet cushions. In Velletri, Caligula gave banquets in a plane tree he called 'The Nest'. In the sixteenth century Cosimo de' Medici amazed Montaigne and Fynnes Morison with the effect of water jets in the trees at the villas of Cartello and Pratolino near Florence. A century later in England the Duke of Bedford was in the habit of climbing up trees to survey the surrounding hunting grounds. The same idea, although in a slightly more humble guise, inspired the creation, between 1850 and the Second World War,

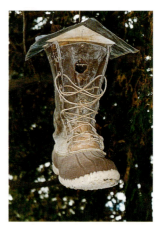

of the '*guinguettes*' of the Robinson district of Paris, the open-air cafés where there was dancing. We find it again in Kenya in 1932 in the Treetops Hotel, run by Mr and Mrs Walker: it provided a natural wildlife observatory. Princess Elizabeth was there on the day she heard that she had succeeded to the British throne.

Hollow trees have less elegant functions. They can serve as shops or temporary storerooms, or as meeting-places for gamblers (in the Montravail oak near Saintes were eight chairs and a table). In the first century AD, the consul Mucianus had circular beds of leaves made up in a hollow tree.

100

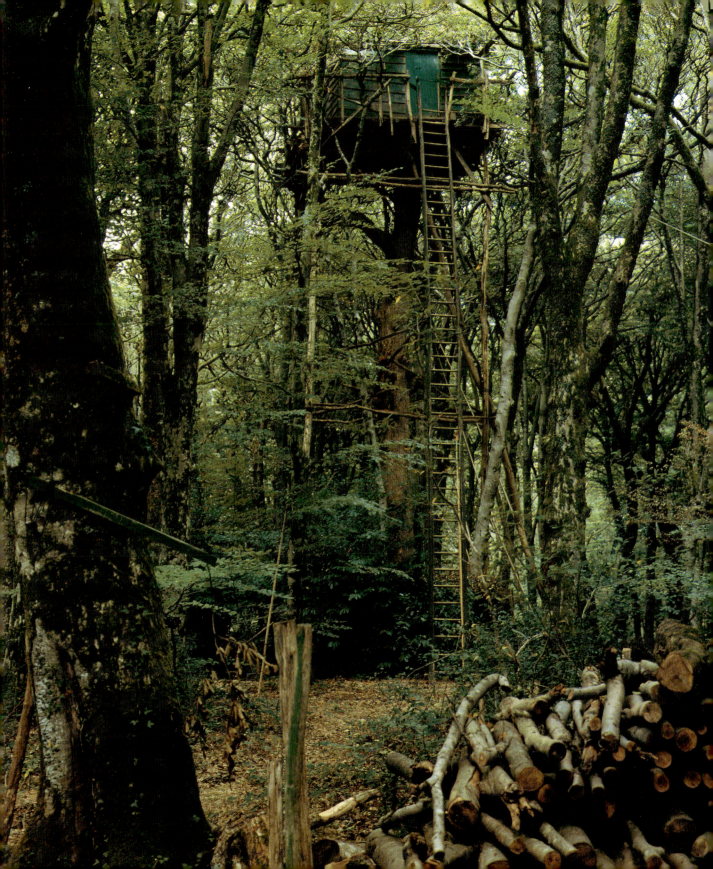

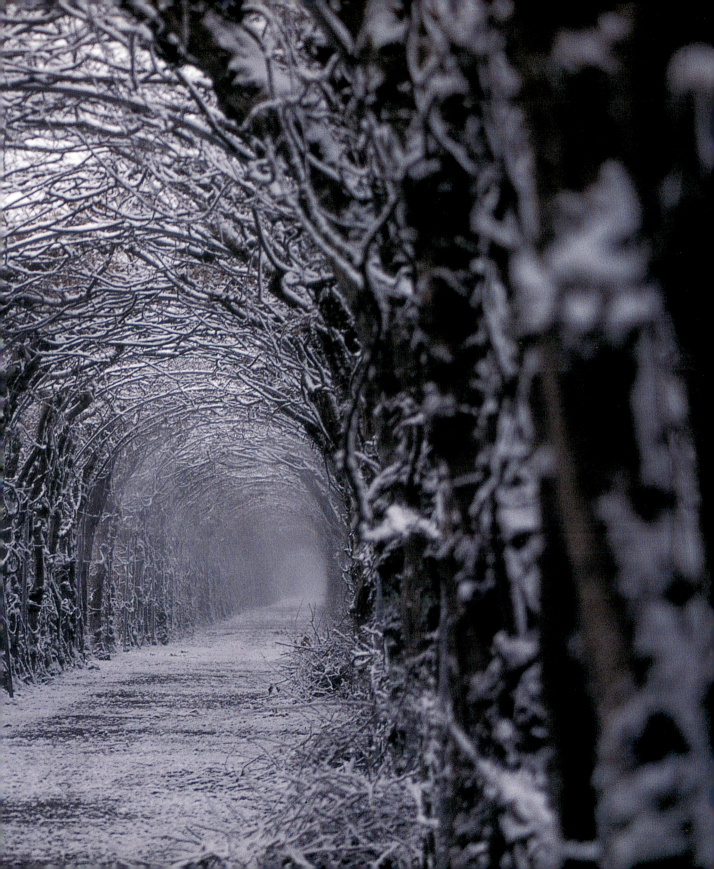

In this natural banqueting-hall, the consul feasted with his guests. Hollow trees have sheltered hermits in Europe and fakirs in India; they have hidden those threatened by wolves (St Francis de Sales) or by enemies (Guillotin the monk during the French Revolution). If they are very wide and stable, like yews, they can be turned into chapels, panelled, wainscoted and furnished. The hollow tree in La Haye-de-Routot in Normandy seems to be associated with fairies, elves, korrigans or even some great djinn with a mocking laugh, whereas the one in Allouville, also in Normandy, is rather more prosaically thought to be situated on top of a well twenty metres (sixty-five feet) high, linking the tunnels that run under two country houses. Long avenues, lined with stately oaks, plane trees, lindens and chestnut trees, serve both to announce and conceal manors and estates. If these are double avenues – a sign of wealth – they offer an elegant and civilized frame for the pedestrian who chooses to walk along the side path rather than tangle with carriages and carts. The very image of the inaccessible and the luxurious, these avenues of chestnut trees – trees that were still at that time exotic and 'new' – were the stuff of dreams in the reign of Louis XV.

104

Page 100: top left, Frans Krajcberg, a concentration camp survivor, built his house in Brazil as a manifesto; it is created in a tree from the shrinking Amazonian rainforest; *below left,* a wild man in a hollow trunk, French, fifteenth century; *centre:* a bird shelter in the U.S.A. *Page 101:* a hunter's cabin in the Béarn in France. *Pages 102–3:* the 4700 trees of the hornbeam arbour at La Reid in Belgium were planted for sheer visual pleasure. *This page, above left:* in 1846, the chestnut trees in the district of Robinson near Paris sheltered *guinguettes* and restaurants; *below left:* the maple tree in Matibo, Piedmont, a favourite pilgrimage for walkers. *Opposite:* in Paris, the 'green salons', praised in Audot's treatise on decorative gardens in 1818, were very fashionable in the early nineteenth century.

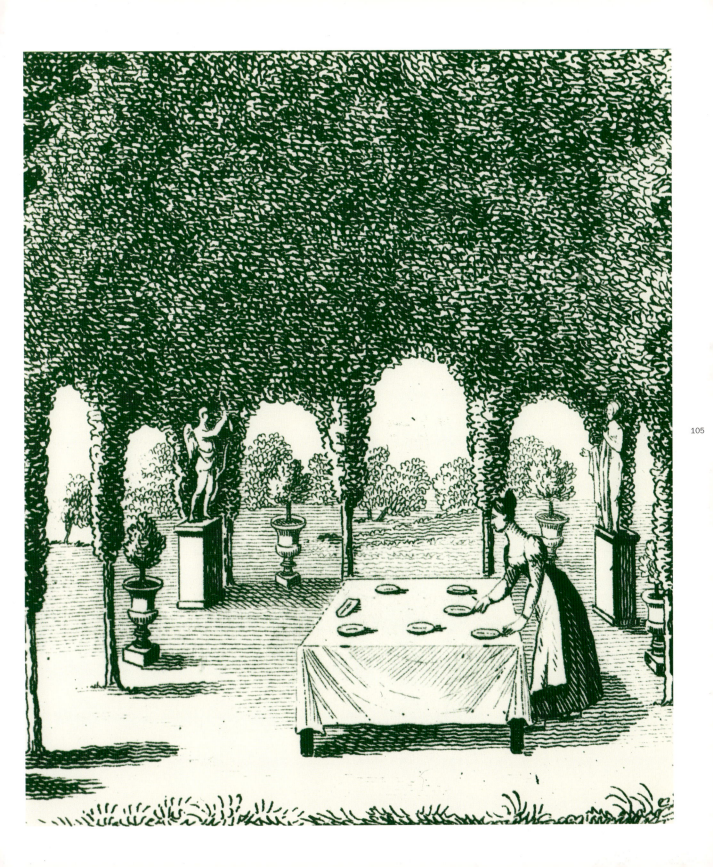

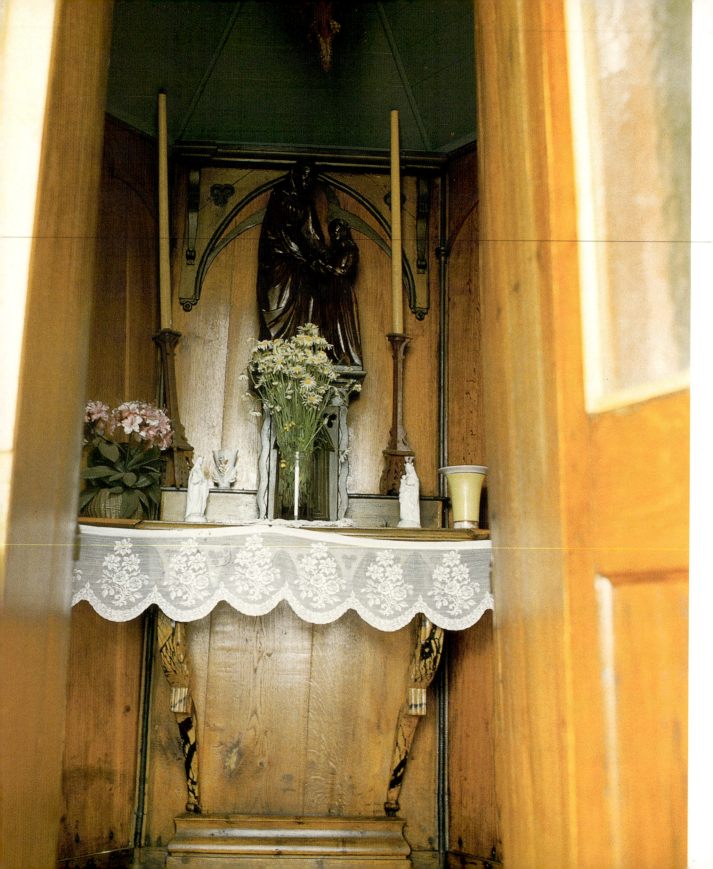

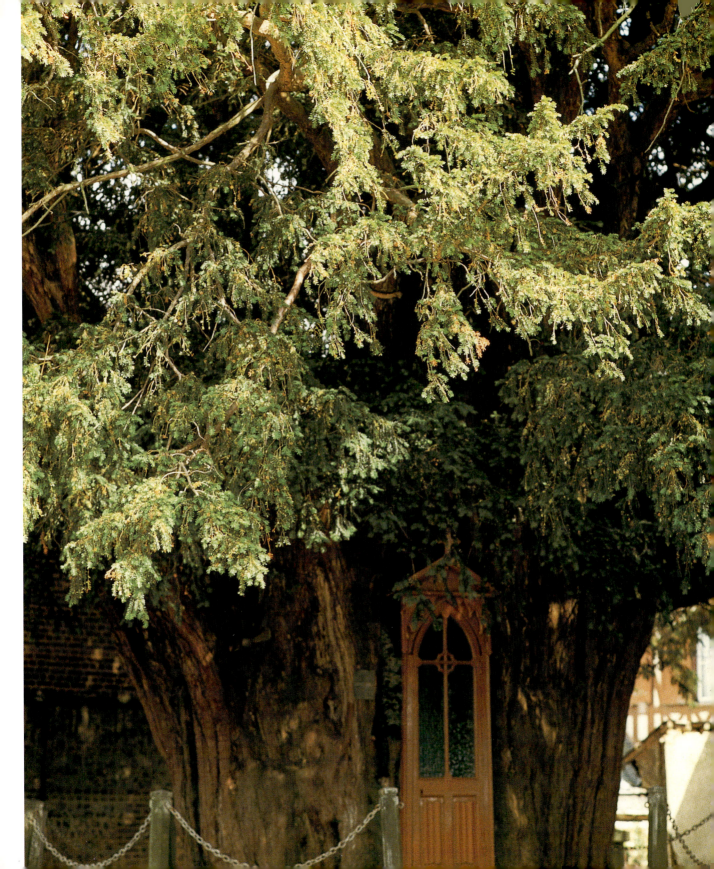

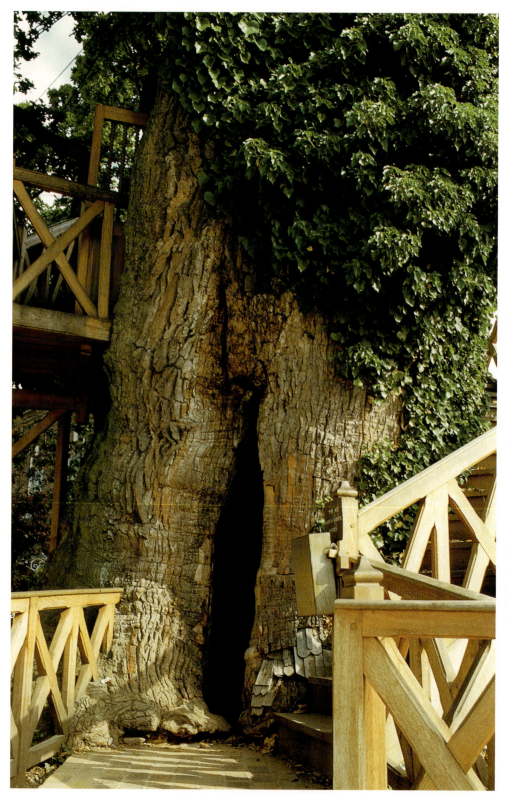

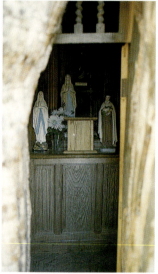

Page106-7: the yew tree of La-Haye-de-Routot has been the object of pagan ritual for centuries. It may be as much as fifteen hundred years old. In the nineteenth century, a Gothic chapel was installed in its trunk; there is also a chapel *(left)*, and a hermit's refuge *(above)*, in the thousand-year-old oak of Allouville in Normandy.

Below: in Eritrea, a Christian chapel in the trunk of an old baobab, a tree that French explorers of the eighteenth century thought

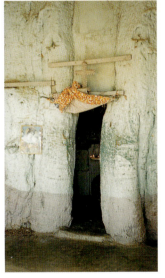

gross and ugly. It is entered through this little sanctuary *(right)*. *Overleaf:* a temple in a banyan tree, and the door which leads into it.

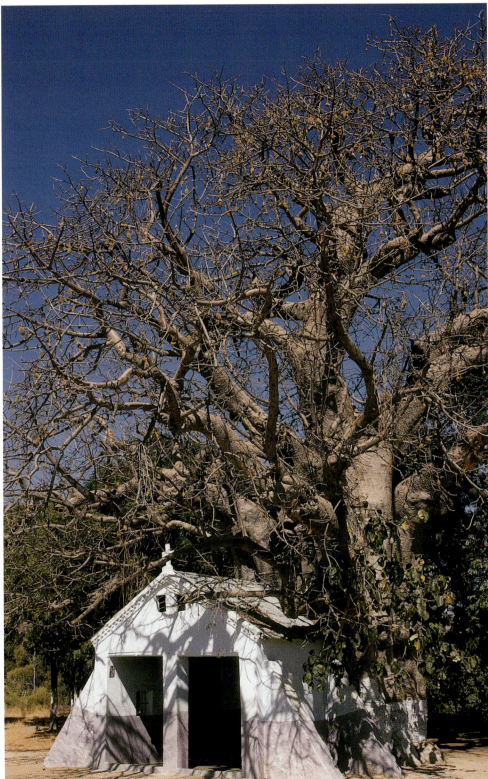

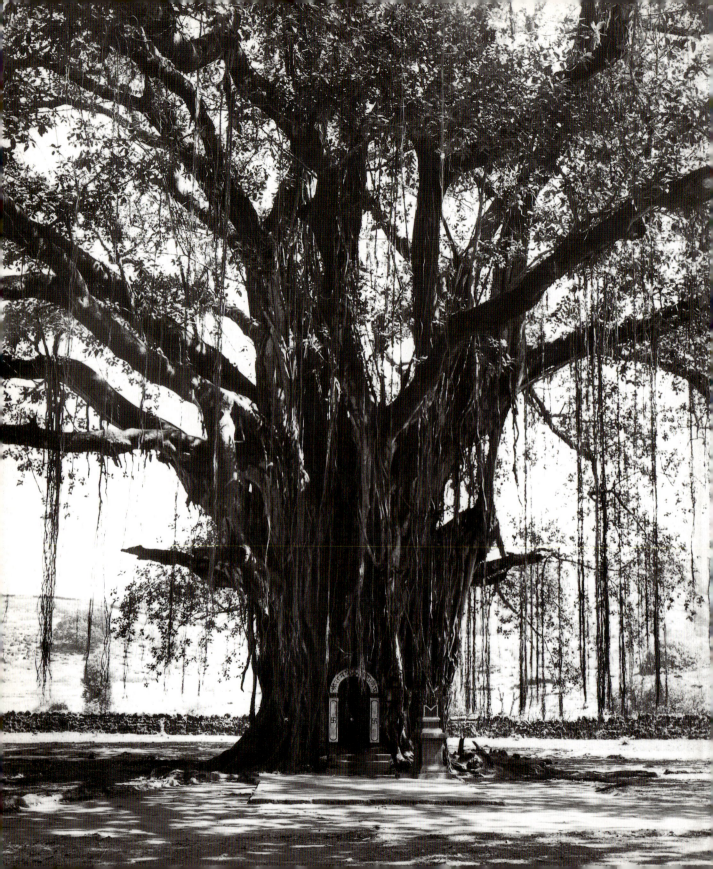

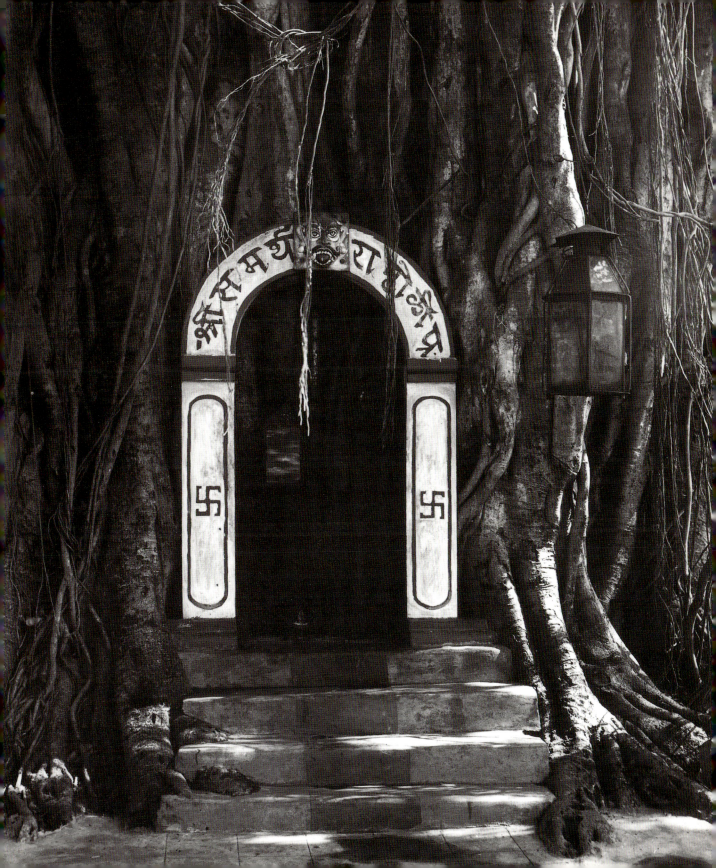

ACKNOWLEDGMENTS

The author would like to thank

Jacques Brosse, whose erudition is a source of great pleasure

P. Aprahamian, S. Bergmann, M. Berro, M. F. Bouchaud, J. J. Breton, C. Brouet
Mary R. Carter, D. Dufayet, A. Emery, D. Gaumont, F. Gilles, M. Hogg, S. Howell,
M. F. Joblin, B. Saalburg, Tessa, F. Teynac, B. Turle, B. Wirth

Caricature of the tree of the French
Revolution – rootless and headless. Göttingen, 1791.